4

Stereo enables Space in Sound

>>

Die Deutsche Bibliothek
Cip Einheitsaufnahme
Mai, Klaus:
SEE! / Klaus Mai.

Text by **Thomas Heise**
Designed by **Klaus Mai**
Edited by **Robert Klanten**
Photo by **Katrin Denkewitz +
Martin Url**

Hrsg.: Robert Klanten – Berlin
dgv – Die Gestalten Verlag, 2000
ISBN 3-931126-43-9

Printed by Medialis Offset, Berlin
Made in Europe.

Designbureau KM7
Schifferstrasse 22, D-60594 Frankfurt, Germany
Fax +49 69 96 21 81-22
www.km7.de E-mail: km7@gmx.de

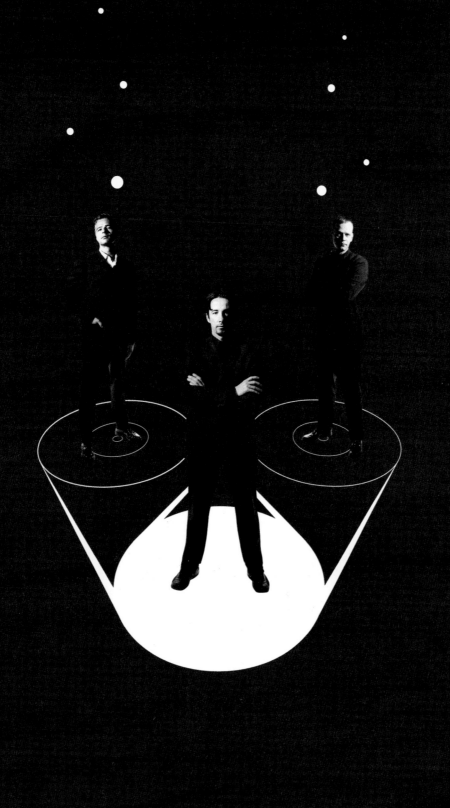

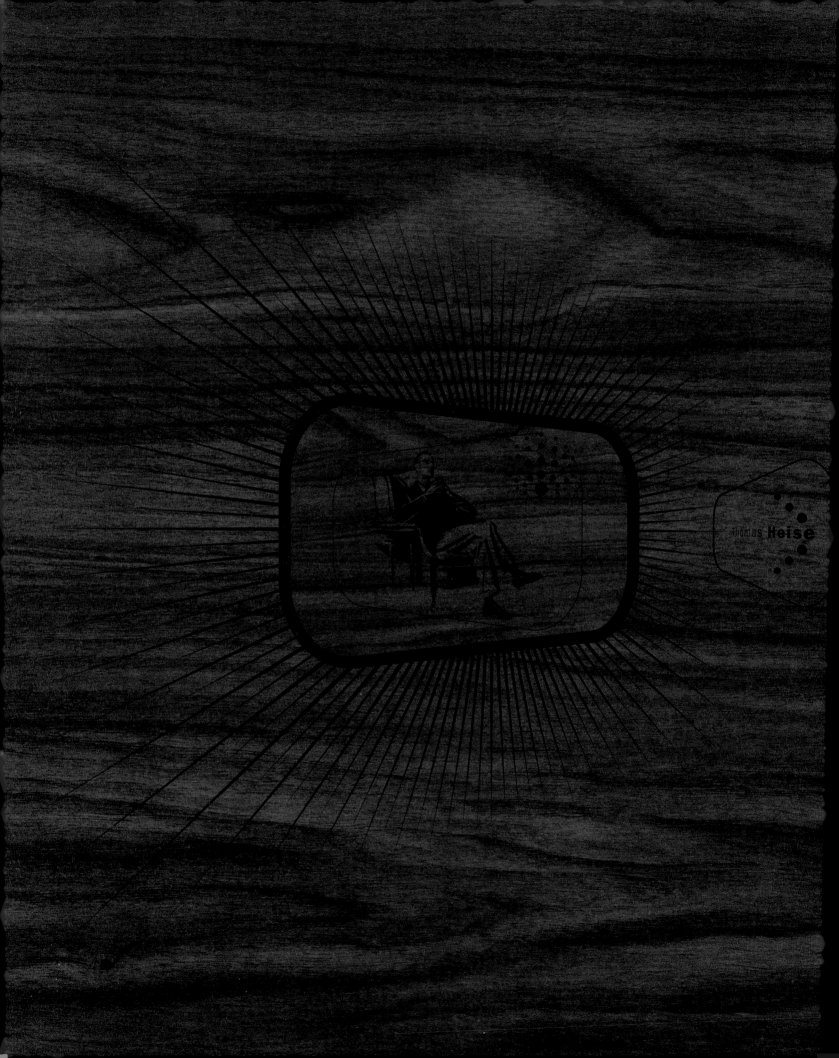

thomas Heise

My heart is set on detail >>

Preface

0 0
7

Example: With me it's all about well-groomed obsessions.

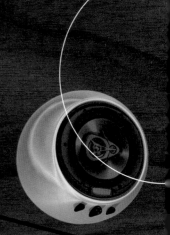

play

My Kind Of

Turn-that-chair burn-that-chair version

Sample: Who knows, but this could be my last book.

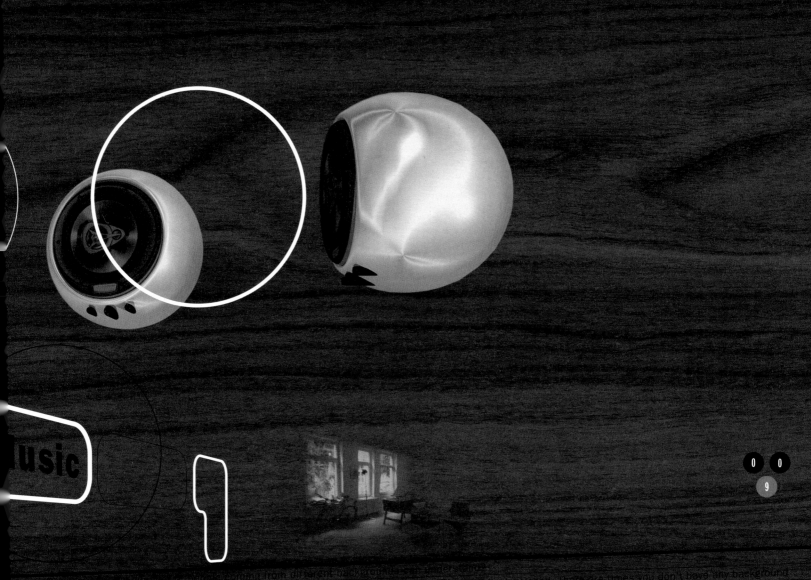

o 2: That's the point. Just like with a good piece of music, you don't know how it was technically developed. There are times you don't have any background information about the music at all. But that doesn't matter, music simply takes a leave within you and together with it your present spirit. And often enough, a lot of people around you experience the same sensation.

o 1: Music plays a big role in your work, and as I understand it, there is more to it that just fulfilling a customer's need. You cannot hear it, but my kind of music

o 2: There are ample parallels. **Rhythm, structure, the variation of themes, that's the kind of music** - my kind of music. You can pick up on it, and feel it just as well. Even in a technical sense, you will find a lot of parallels. Sampel, electronic modifications, and mix can be found [...], and that's also the case with my work which is mainly processed with my computer. There even are those remixes. A remix of a visual theme. Something you are likely to find in this book. It was the only way I could condense and show a more complex topic, such as a pathfinder for a TV channel using a bunch of pics. I guess you could say that I adapted the TV effect for the pages of a book.

o 1: **"24-hours-MTV-on-just-two-pages" -Mix?**

o 2: In the **"Turn-that-chair-burn-that-chair"-version**. And in the end, it really does work like a piece of music - more on the emotional level. You don't [...]

o 1: What kind of approach do you take with them?

o 2: I strongly focus on and talk about the brand of the company [...]

o 1: "So, you're telling me that safe ground is important?"

0 1

0

Silberpfeil

But, what a fantastic project it turned out to be. In my opinion, the Audi TT and the TT Roadster are literally the only two cars that are beyond t
retro hype and demonstrate a new independent design.

Beyond the **retro hype**

Sample:

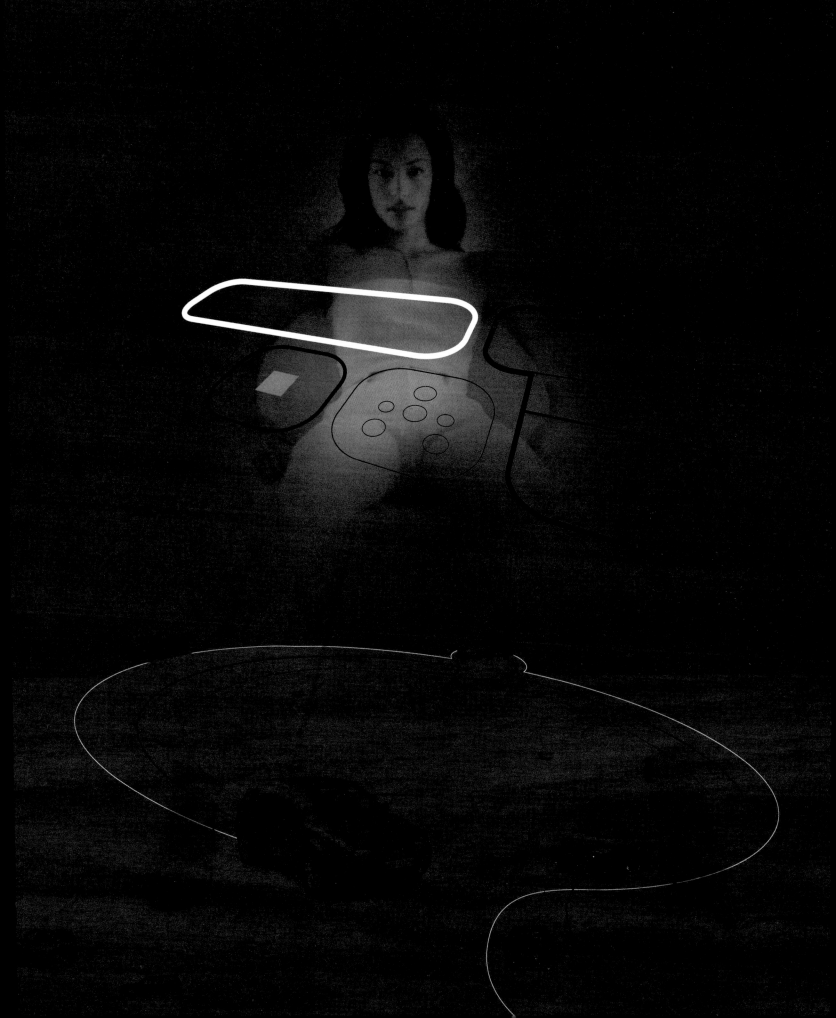

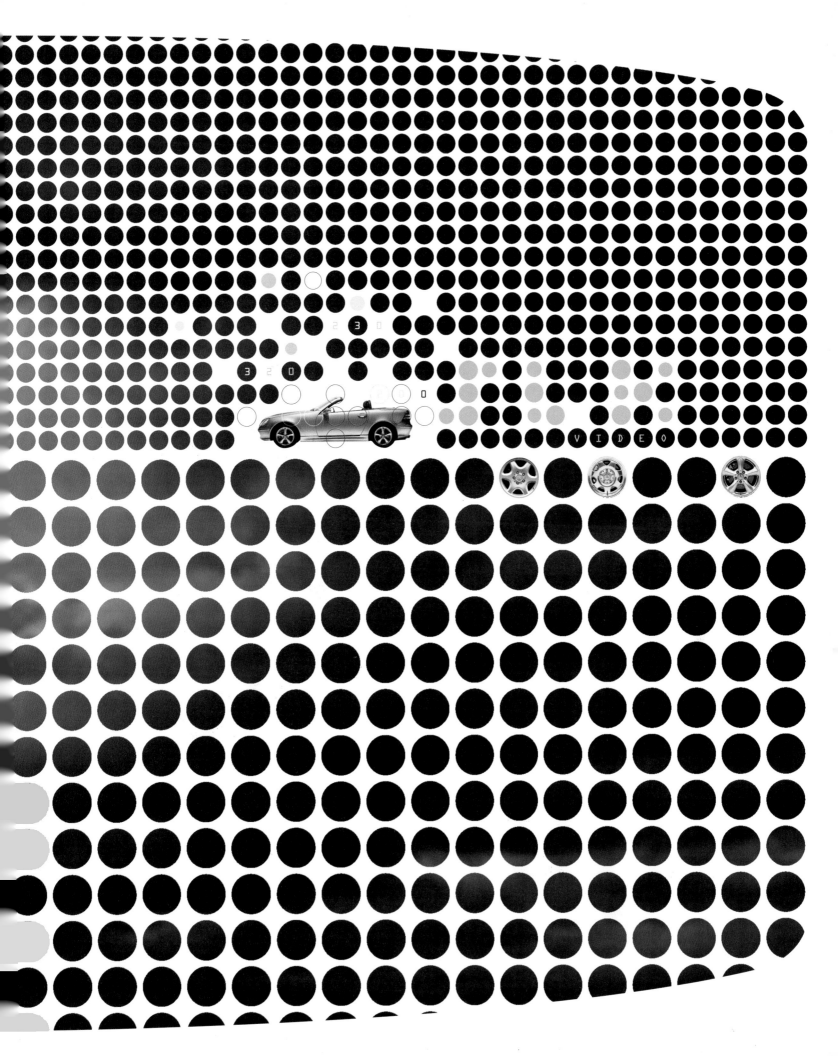

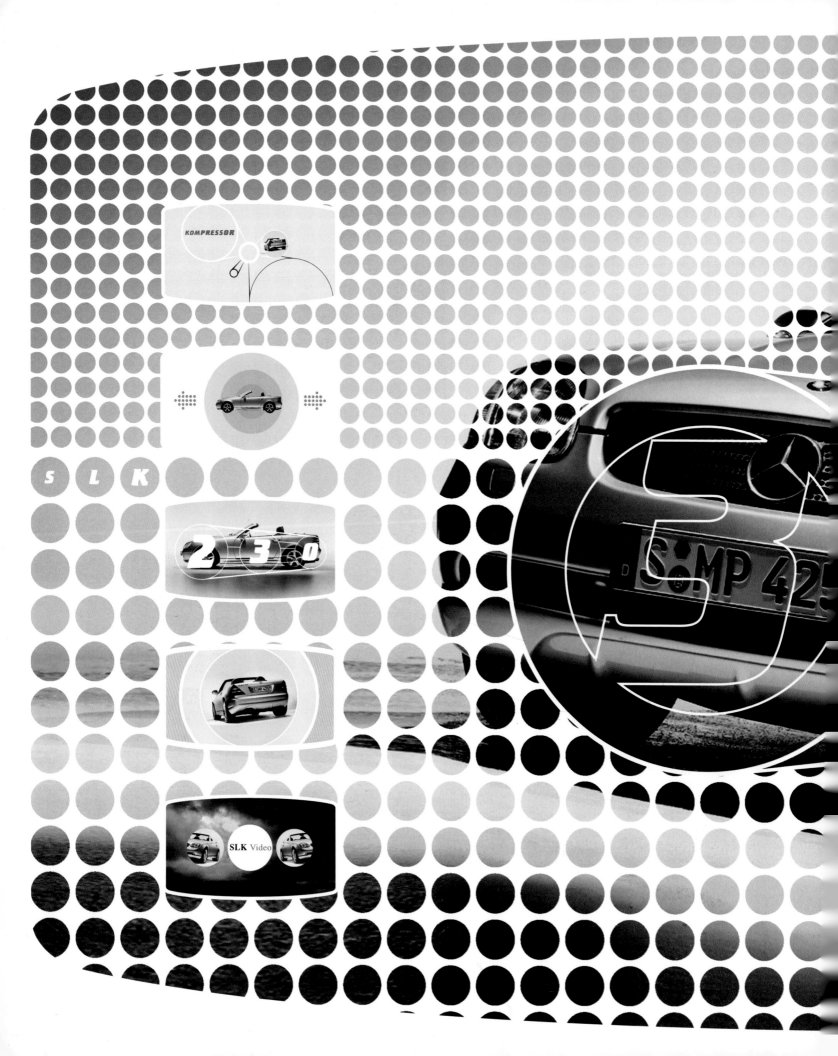

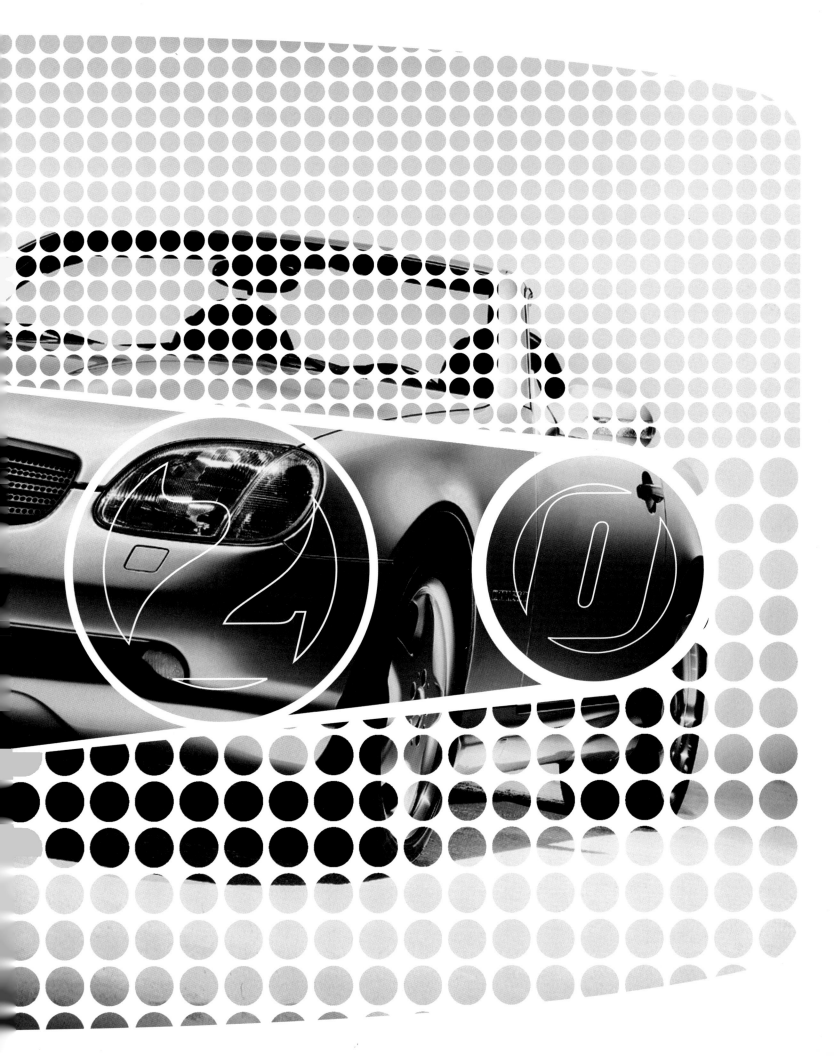

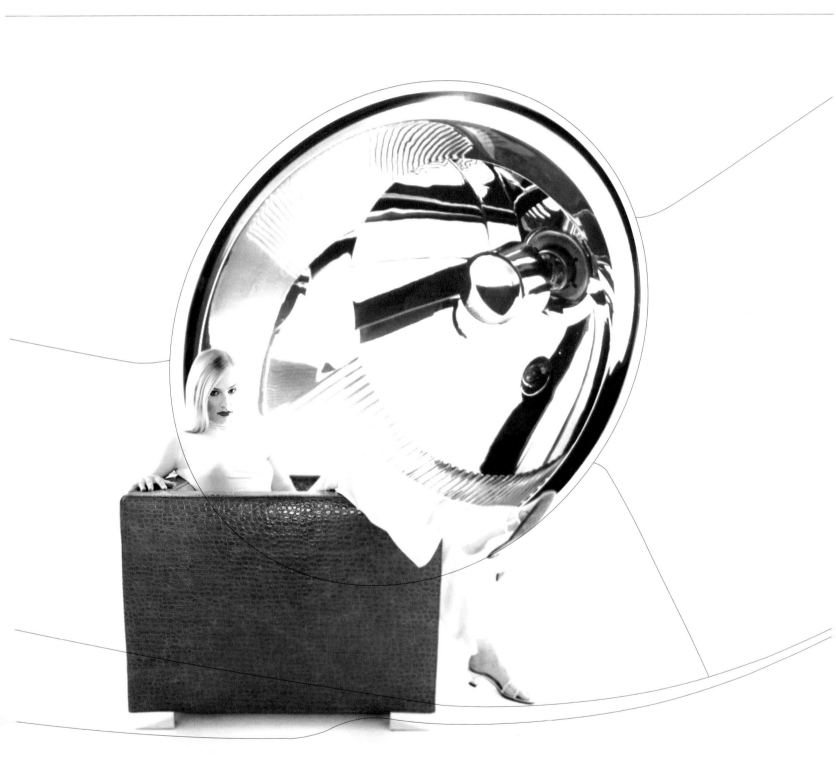

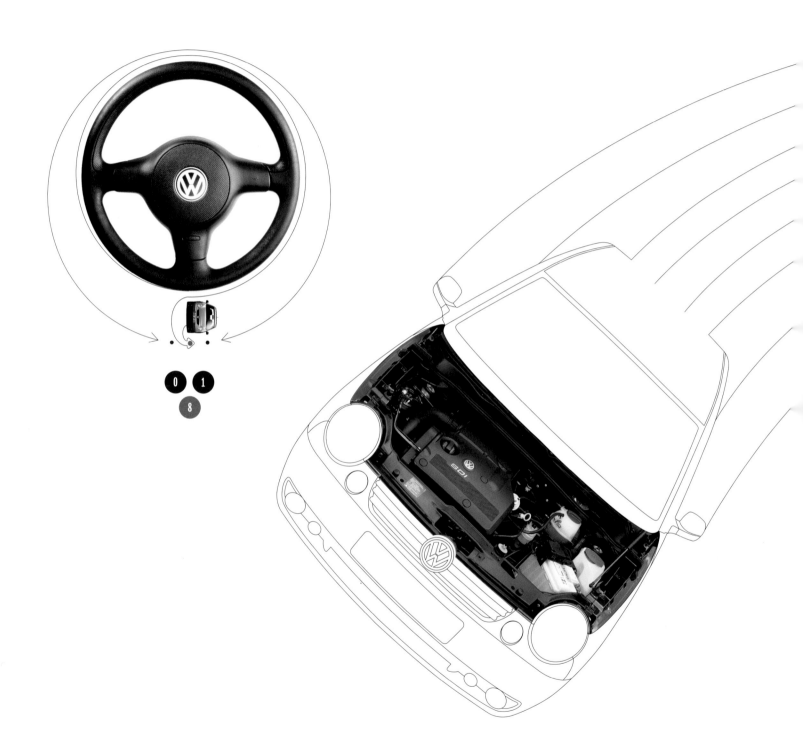

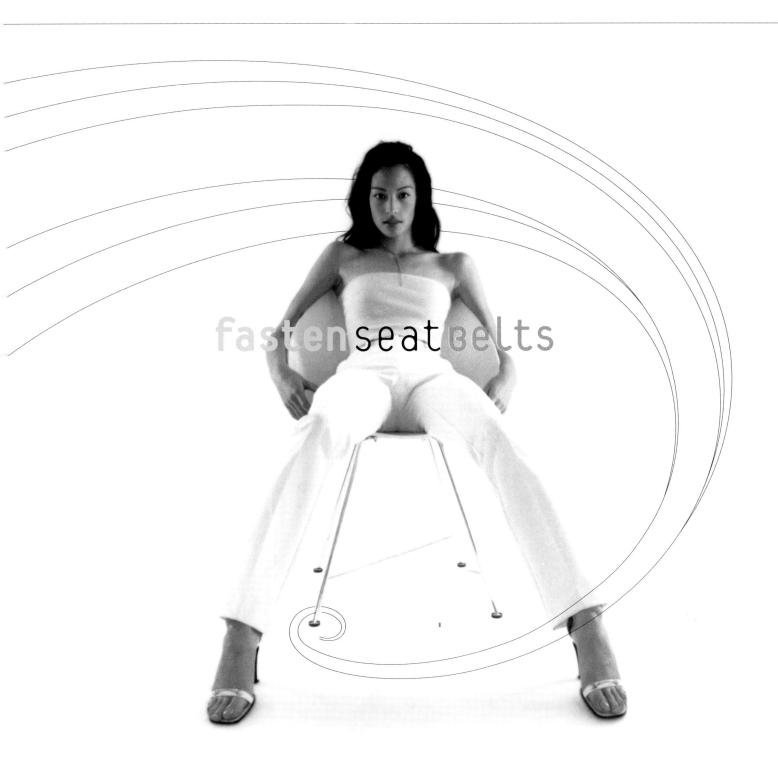

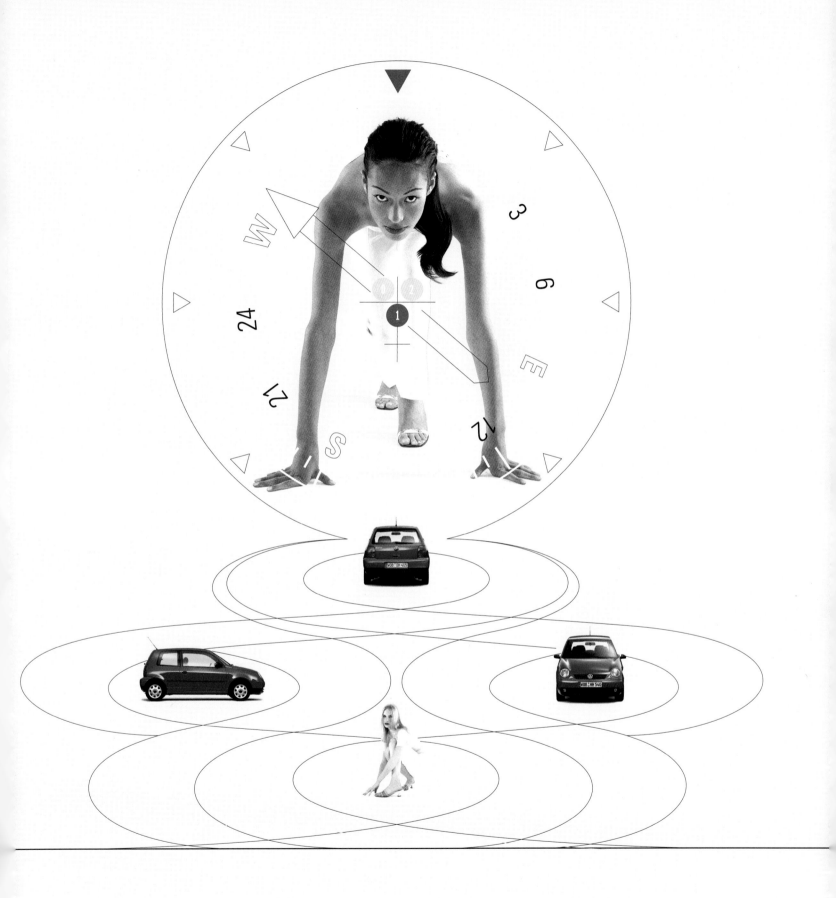

Lupo

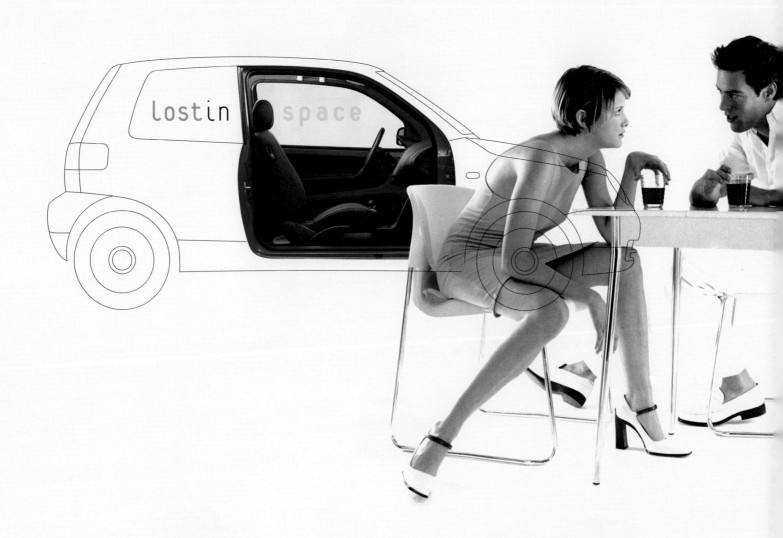

lostin space

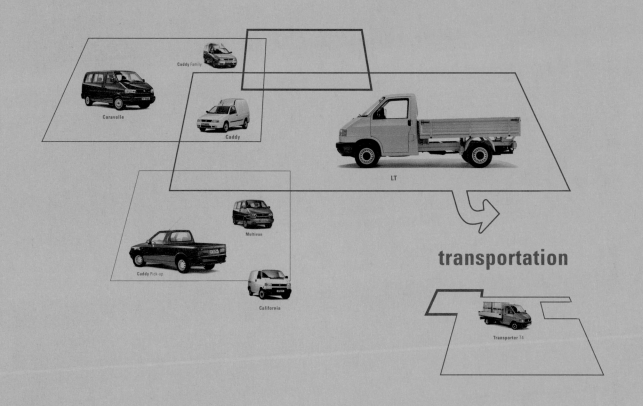

Caddy Family

Caravelle

Caddy

LT

Multivan

Caddy Pick-up

California

transportation

Transporter T4

fastforw

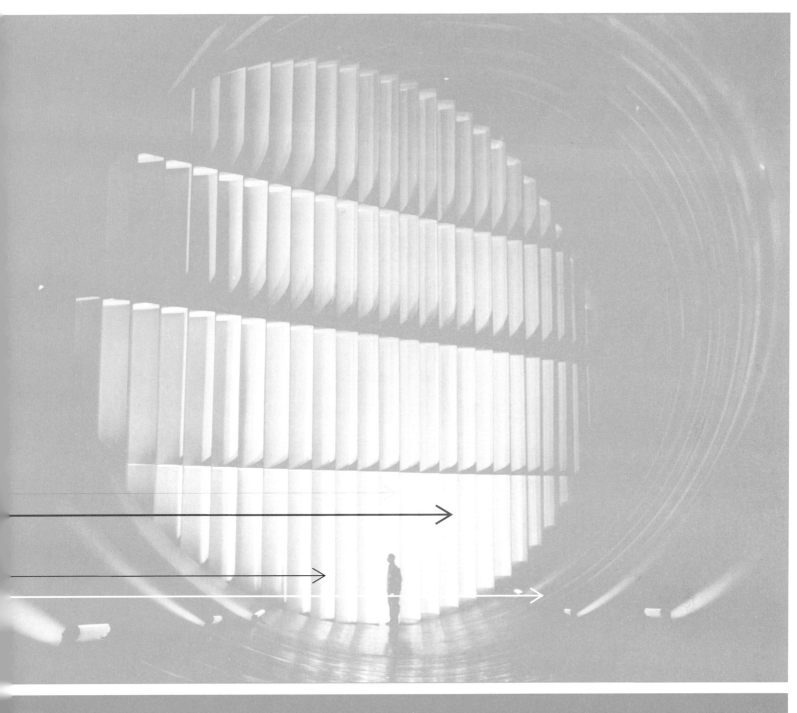

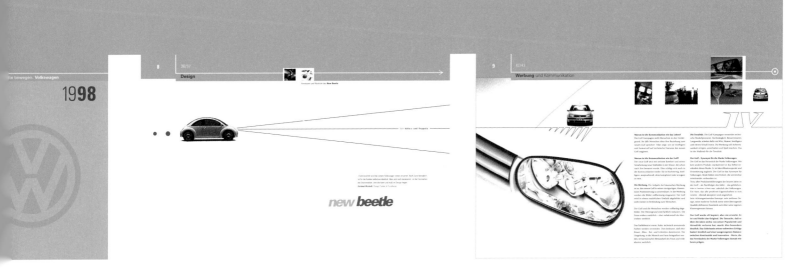

lie bewegen. **Volkswagen**

1998

8 36/37
Design

9 42/43
Werbung und Kommunikation

new **beetle**

Technik

Vroooom

Motoren der Zukunft

worldpremiere

1 Auto Union Typ C Stromlinie
Hergestellt, 1:18 auf Vakuette-Motormodell silbermetalenc.
Spielersteller. Original-Revival-Serif-Max
Best.-Nr.: 3.00.000.00002

DER A4 HOCH 3

A4-TUNING

COLLECTION

Driven by **instinct**

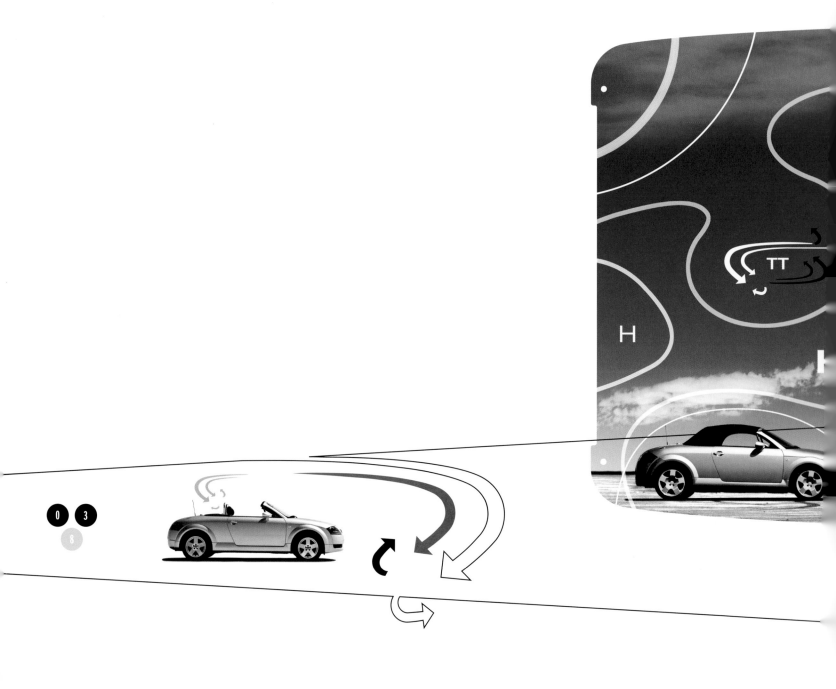

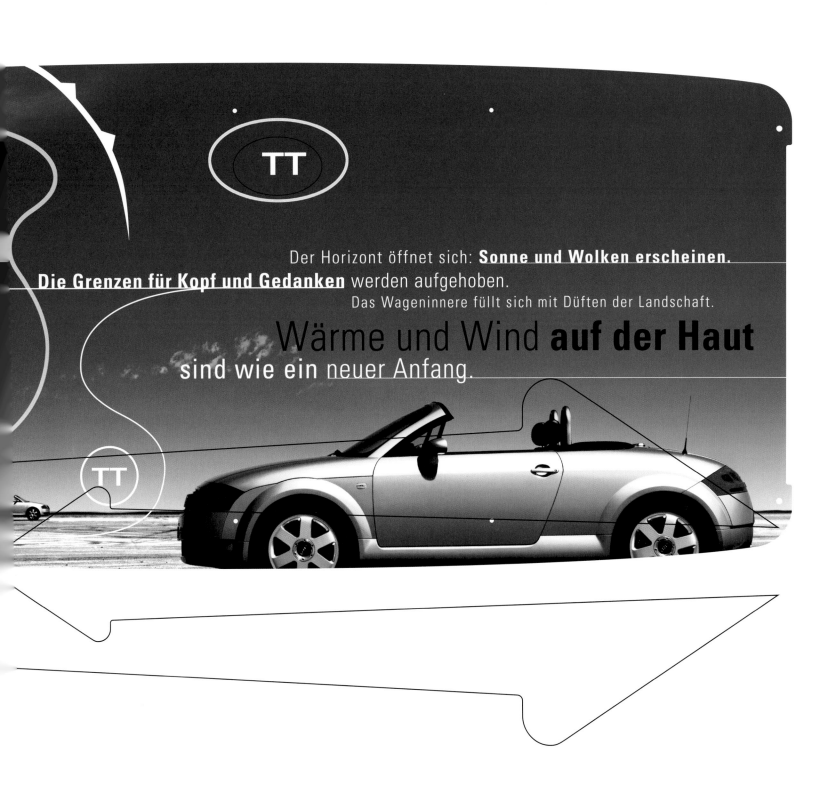

Der Horizont öffnet sich: **Sonne und Wolken erscheinen.**
Die Grenzen für Kopf und Gedanken werden aufgehoben.
Das Wageninnere füllt sich mit Düften der Landschaft.
Wärme und Wind **auf der Haut**
sind wie ein neuer Anfang.

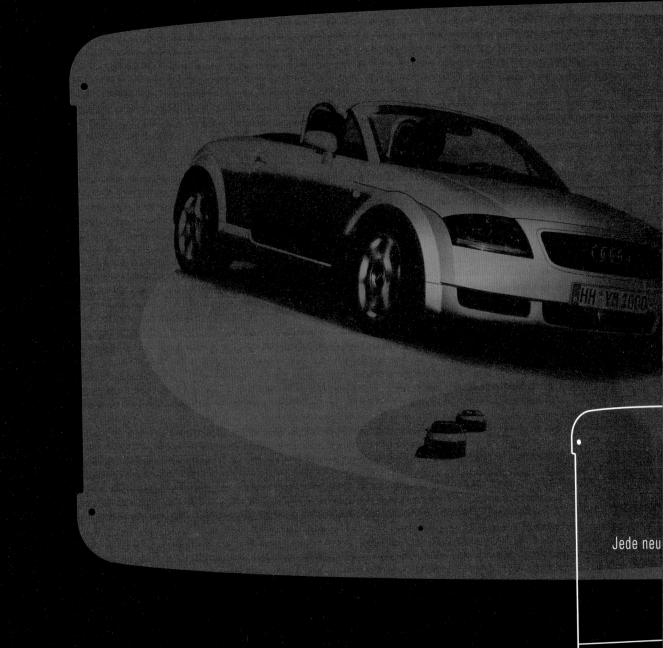

Jede neu

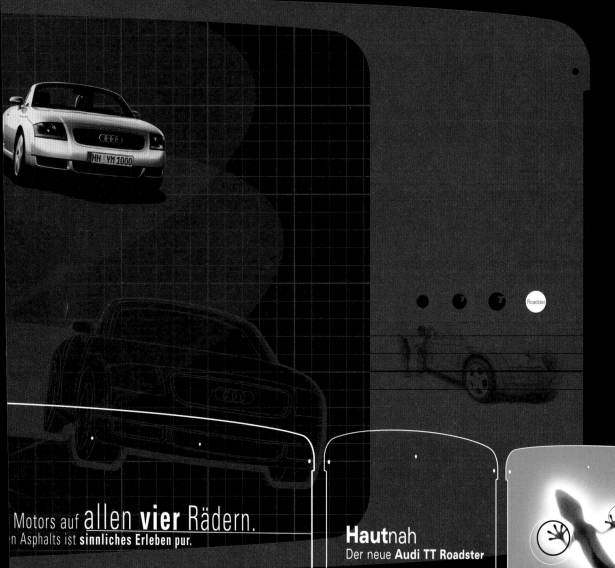

Motors auf **allen vier** Rädern.
n Asphalts ist **sinnliches Erleben pur.**

auer aus Anspannung und Entspannung
durchfließen **die Haut.**

Hautnah
Der neue **Audi TT Roadster**

Driven by **instinct**

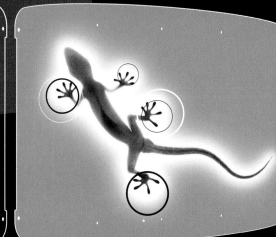

Offen und trotzdem keine Sekunde ausgeliefert.
In direktem Kontakt zur Straße und gleichzeitig mit sicherem Abstand zur **freiwerdenden Kraft.**

Das Spiel der Haare im Wind
hat eine Bühne aus solidem Stahl und leichtem Aluminium.

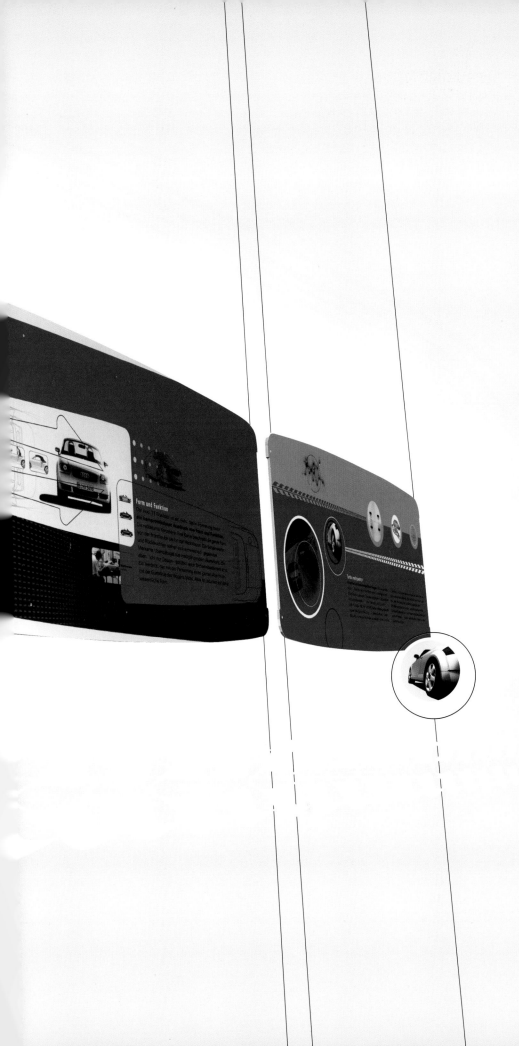

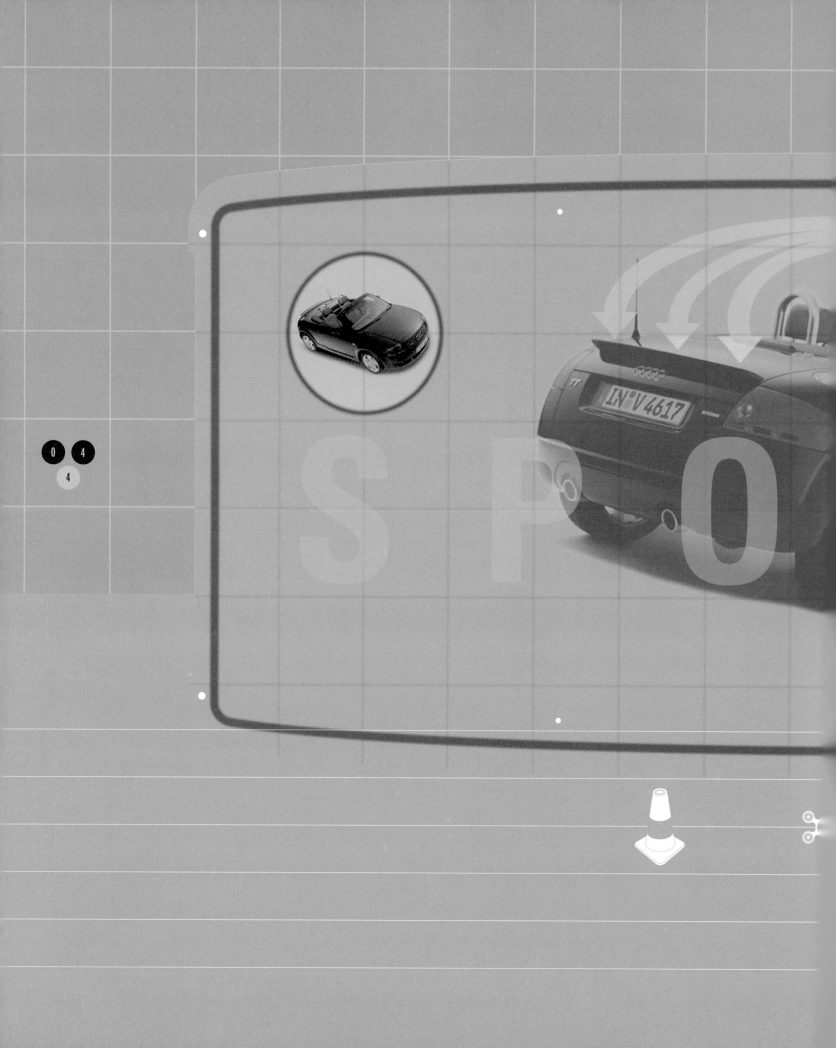

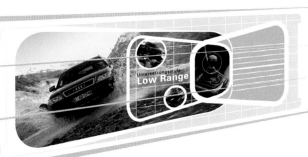

Untersetzungsstufe
Low Range

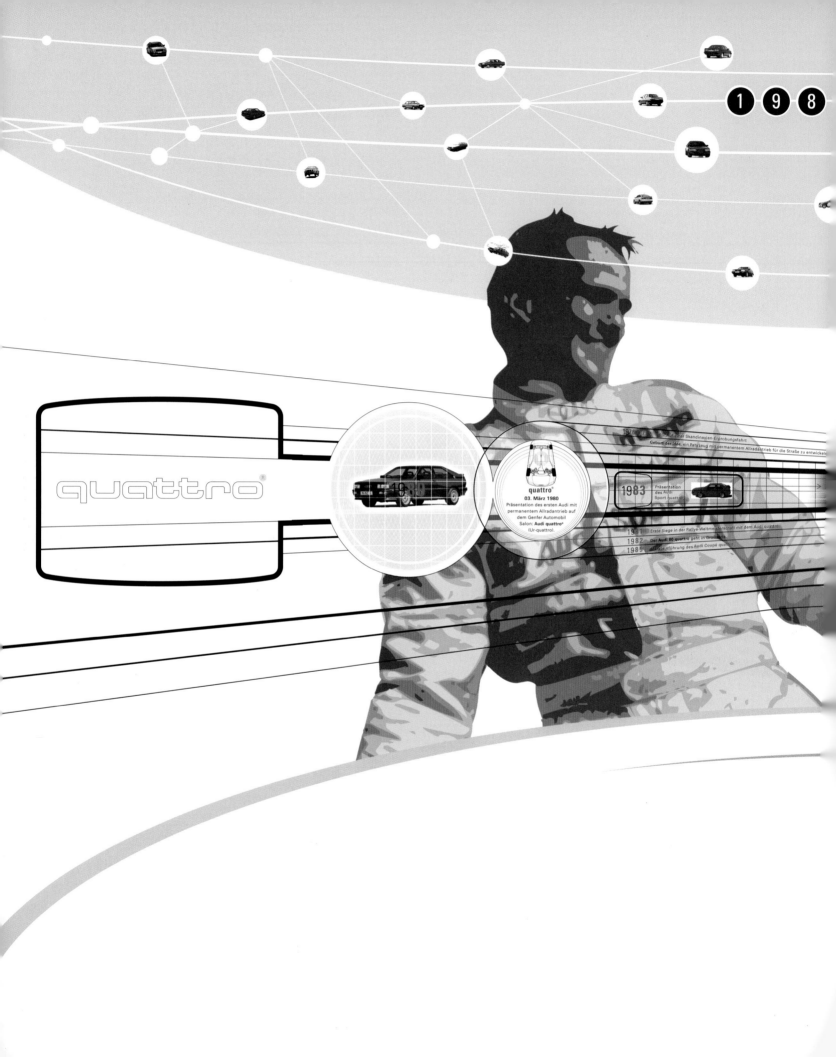

quattro®

quattro®
03. März 1980
Präsentation des ersten Audi mit
permanentem Allradantrieb auf
dem Genfer Automobil
Salon: **Audi quattro®**
(Ur-quattro).

19/6... Auf einer Skandinavien-Erprobungsfahrt
Geburt der Idee, ein Fahrzeug mit permanentem Allradantrieb für die Straße zu entwickeln

1983 Präsentation
 des Audi
 Sport quattro®

1971 Erste Siege in der Rallye-Weltmeisterschaft mit dem Audi quattro
1982 Der Audi 80 quattro geht in Großserie
1985 Markteinführung des Audi Coupé quattro

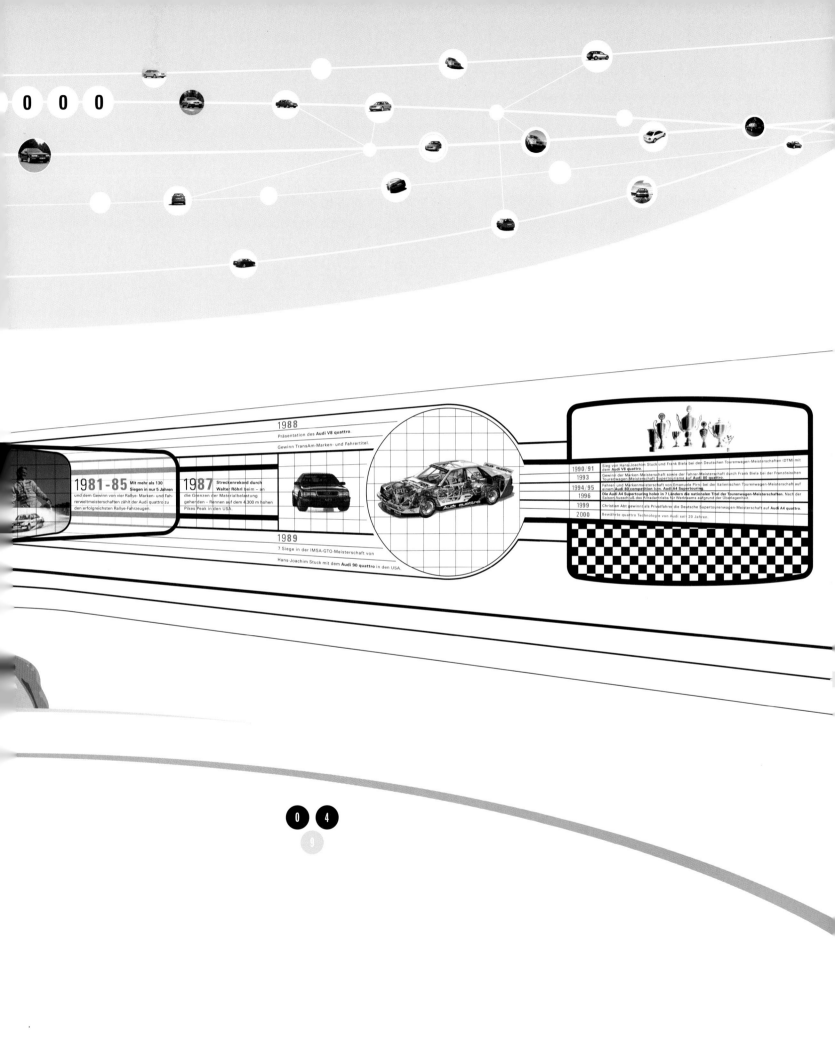

000

1988
Präsentation des **Audi V8 quattro**.
Gewinn TransAm-Marken- und Fahrertitel.

1981-85 Mit mehr als 130 Siegen in nur 5 Jahren und dem Gewinn von vier Rallye-Marken- und Fahrerweltmeisterschaften zählt der Audi quattro zu den erfolgreichsten Rallye-Fahrzeugen.

1987 Streckenrekord durch **Walter Röhrl** beim – an die Grenzen der Materialbelastung gehenden – Rennen auf dem 4.300 m hohen Pikes Peak in den USA.

1989
7 Siege in der IMSA-GTO-Meisterschaft von Hans-Joachim Stuck mit dem **Audi 90 quattro** in den USA.

1990/91	Sieg von Hans-Joachim Stuck und Frank Biela bei den Deutschen Tourenwagen-Meisterschaften (DTM) mit dem **Audi V8 quattro**.
1993	Gewinn der Marken-Meisterschaft sowie der Fahrer-Meisterschaft durch Frank Biela bei der Französischen Tourenwagen-Meisterschaft Supertourisme auf **Audi 80 quattro**.
1994/95	Fahrer- und Markenmeisterschaft von Emanuele Pirro bei der Italienischen Tourenwagen-Meisterschaft auf einem Audi 80 competition bzw. **Audi A4 Supertouring**.
1996	**Die Audi A4 Supertouring holen in 7 Ländern die nationalen Titel der Tourenwagen-Meisterschaften.** Nach der Saison Ausschluß des Allradantriebs für Werkteams aufgrund der Überlegenheit.
1999	Christian Abt gewinnt als Privatfahrer die Deutsche Supertourenwagen-Meisterschaft auf **Audi A4 quattro**.
2000	Bewährte quattro Technologie von Audi seit 20 Jahren.

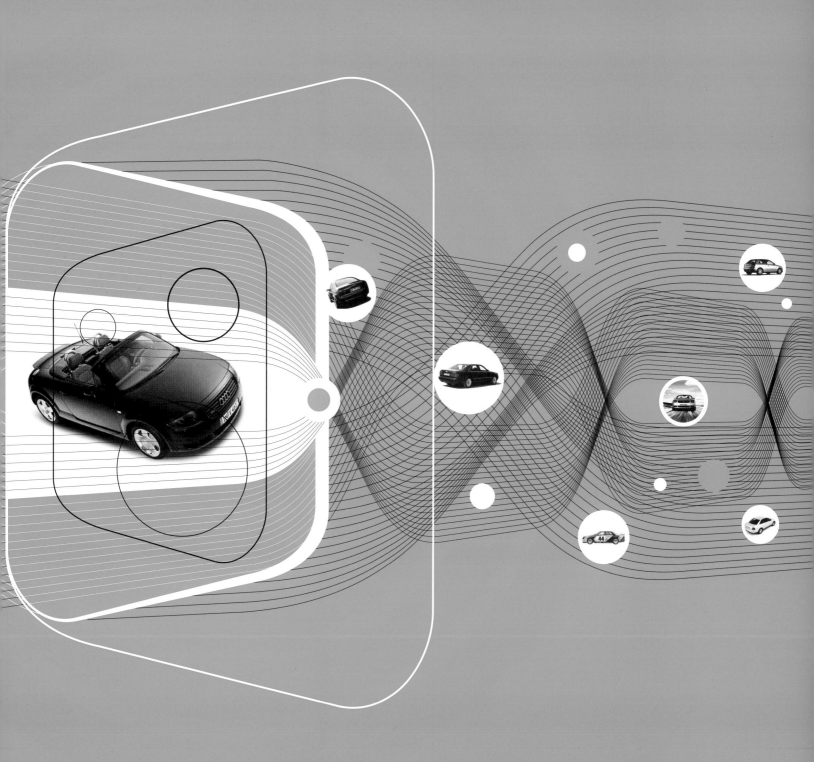

0 5

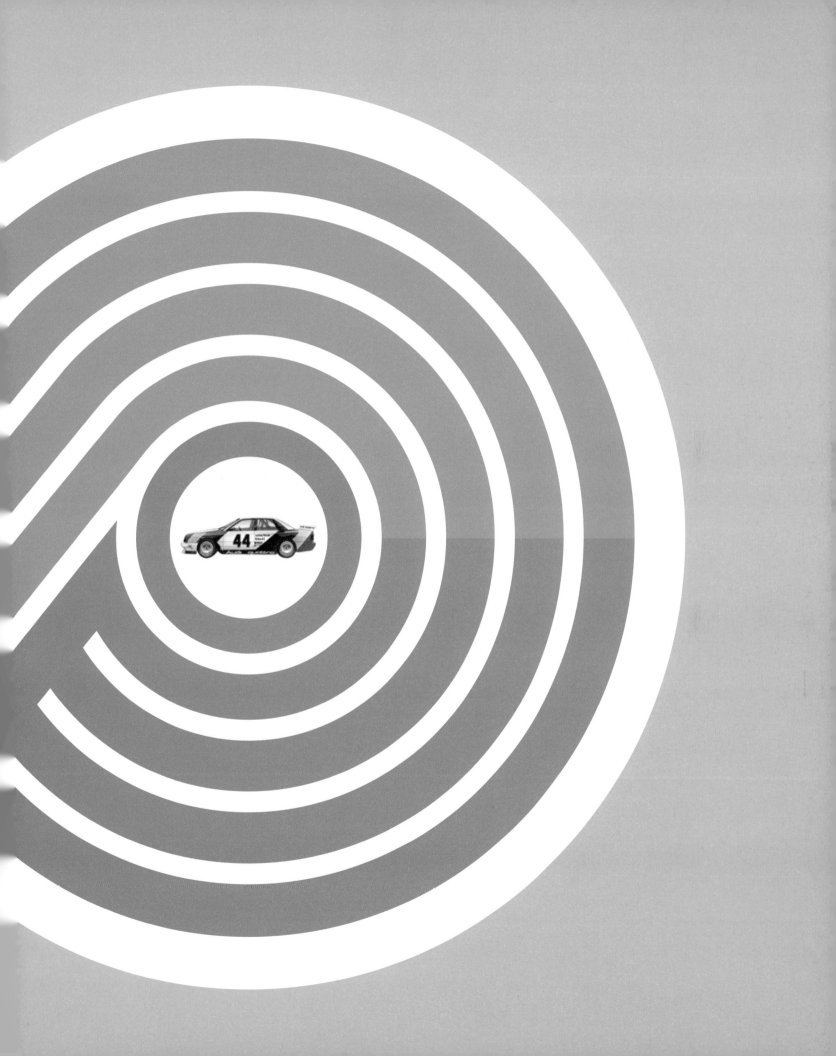

The Real
Kick

Sample:) I was part of the **"Puma League"**

How about something with lawn.

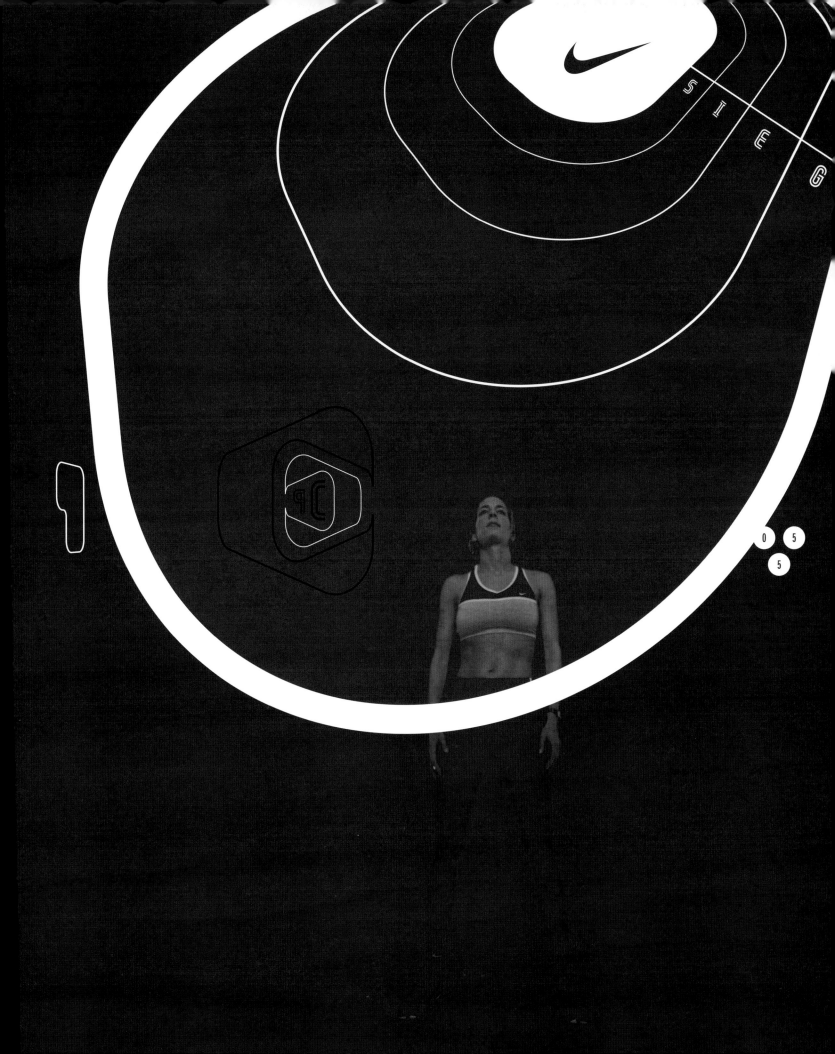

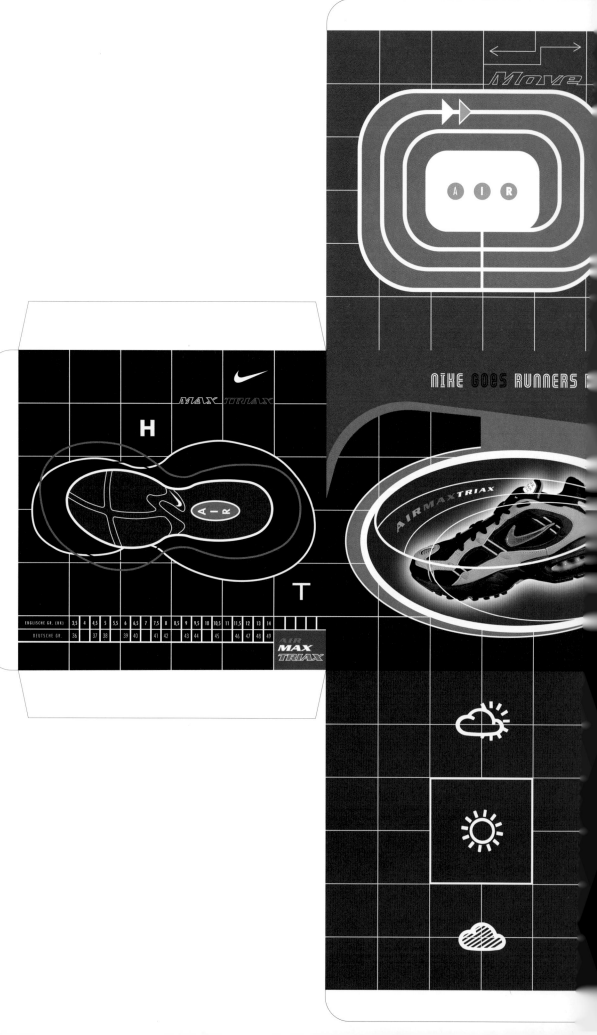

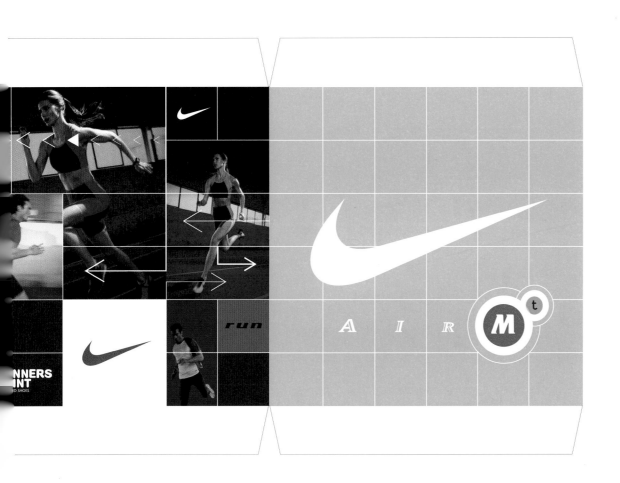

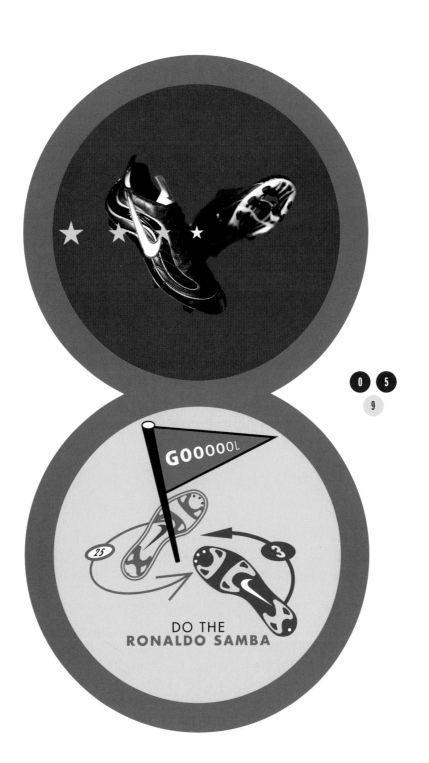

PREMIER

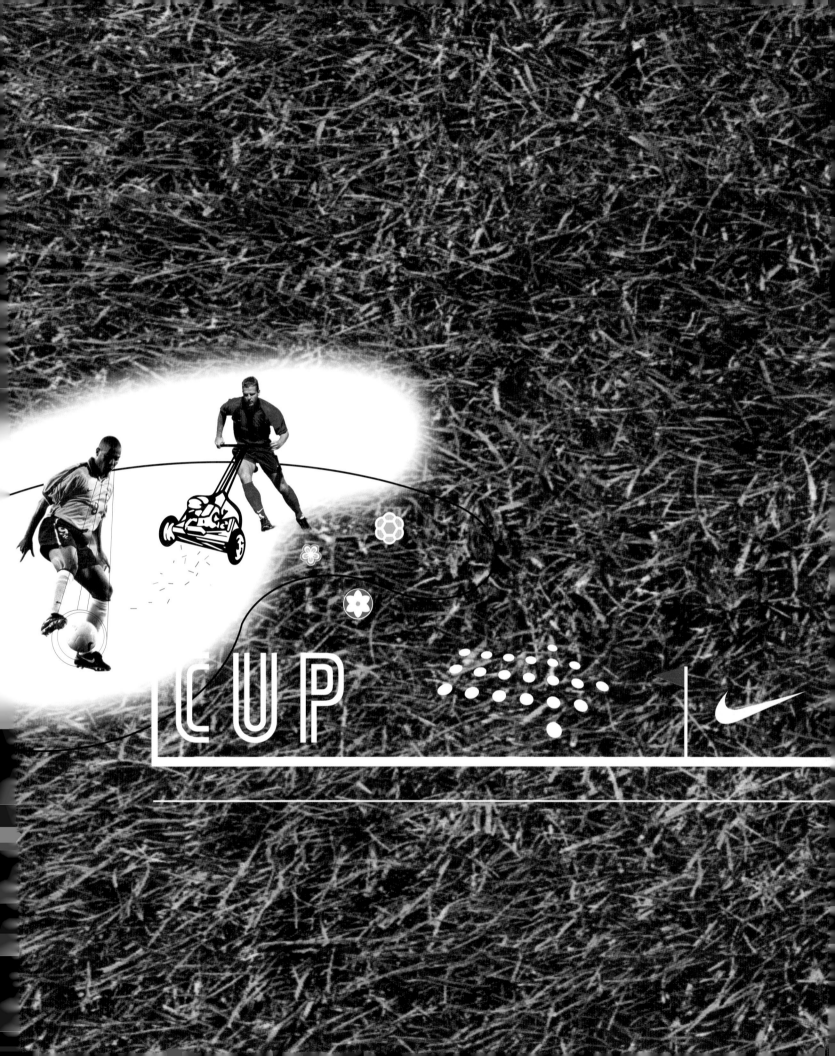

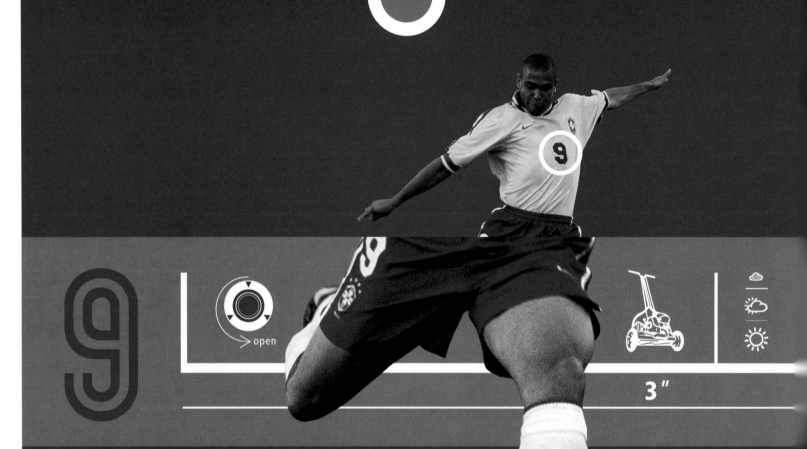

9

open

3"

0 6
2

PREMIER

CUP

99 | NIKE INTERNATIONAL PREMIER CUP

VORWORT VON OLIVER BIERHOF

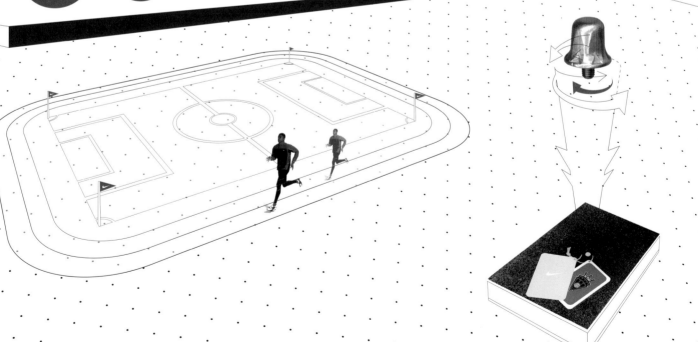

ALLGEMEINE BEDINGUNGEN NIKE INTERNATIONAL PREMIER CUP

1999-2000

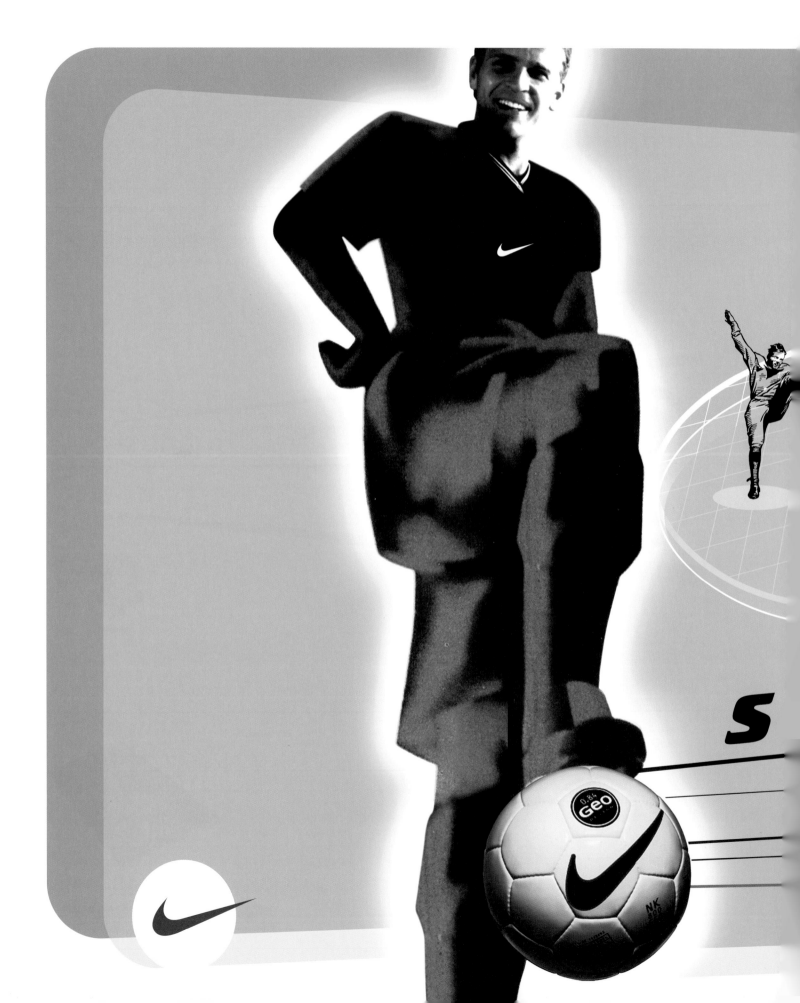

ICK

MICH Steil!

Hol Dir **Oliver Bierhoff** an die Schule

What could those be? **Audio 1:**

What is there to show anyway? As it happens, it is typical that at the very beginning you are confronted with
that good old "nothing". The majority of records are projects realized by music producers and recorded by **Audio 2:**
studio musicians. There is neither live performance nor a band look which I could use as visual input.

0 6

6

ſ

Roy in fron
ρ

Limbo Without

A Pol

al background

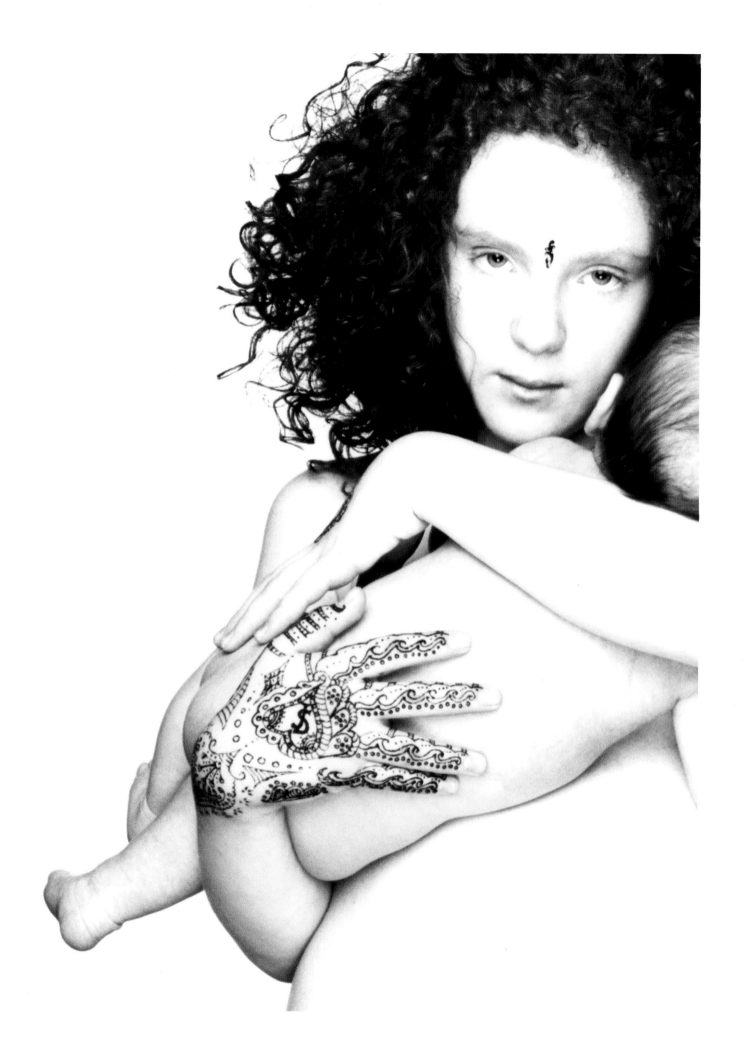

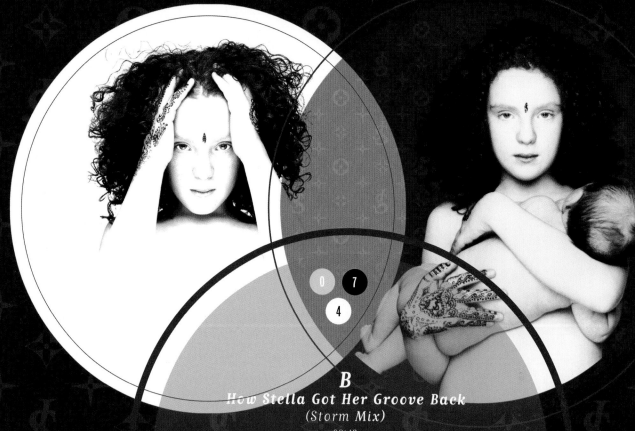

B

How Stella Got Her Groove Back
(Storm Mix)
09:43

Written by *Jam El Mar, Mark Spoon*
Publisher: *Edition Allstar BMG Ufa Edition Subliminal BMG Ufa*

Foto: *Michael Schwab*
Styling: *Barbara Hostalka*

DANCE POOL

5 099766 717463

JAM **667174 6**

2002

Tripomatic Fairytales

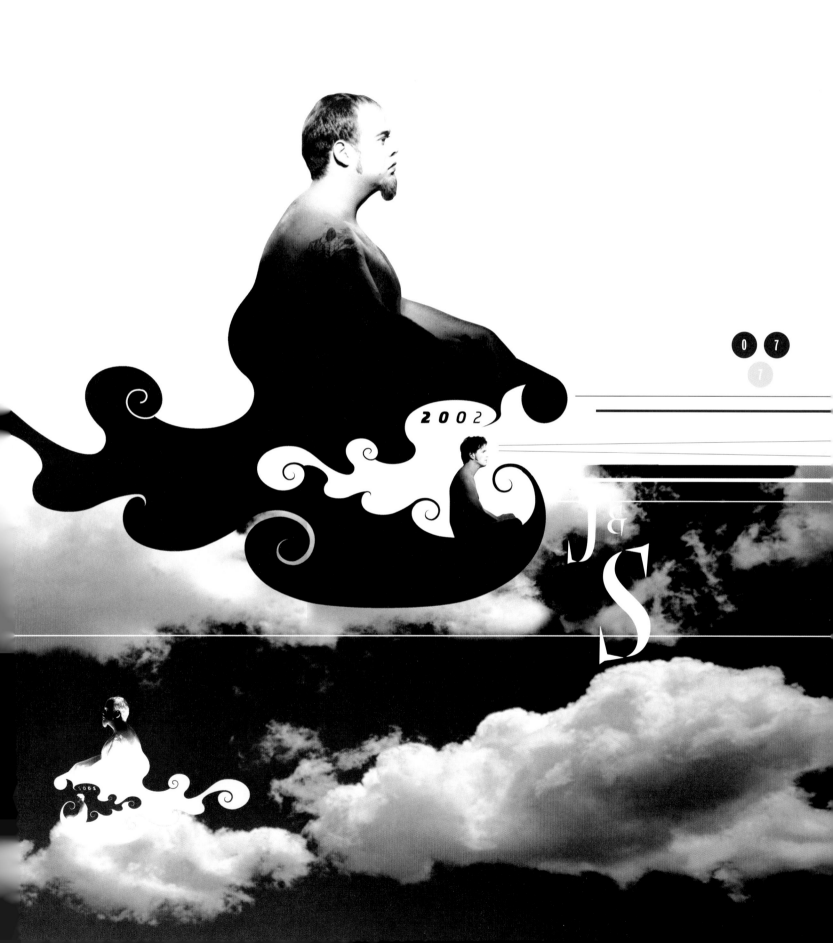

2002

2002

J & S

07
8

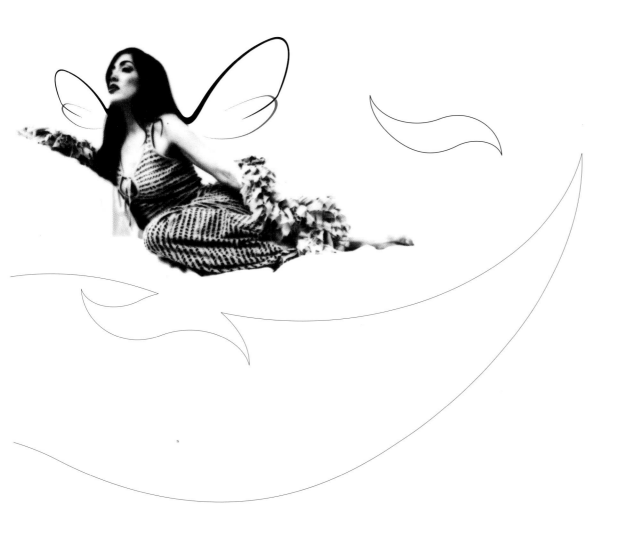

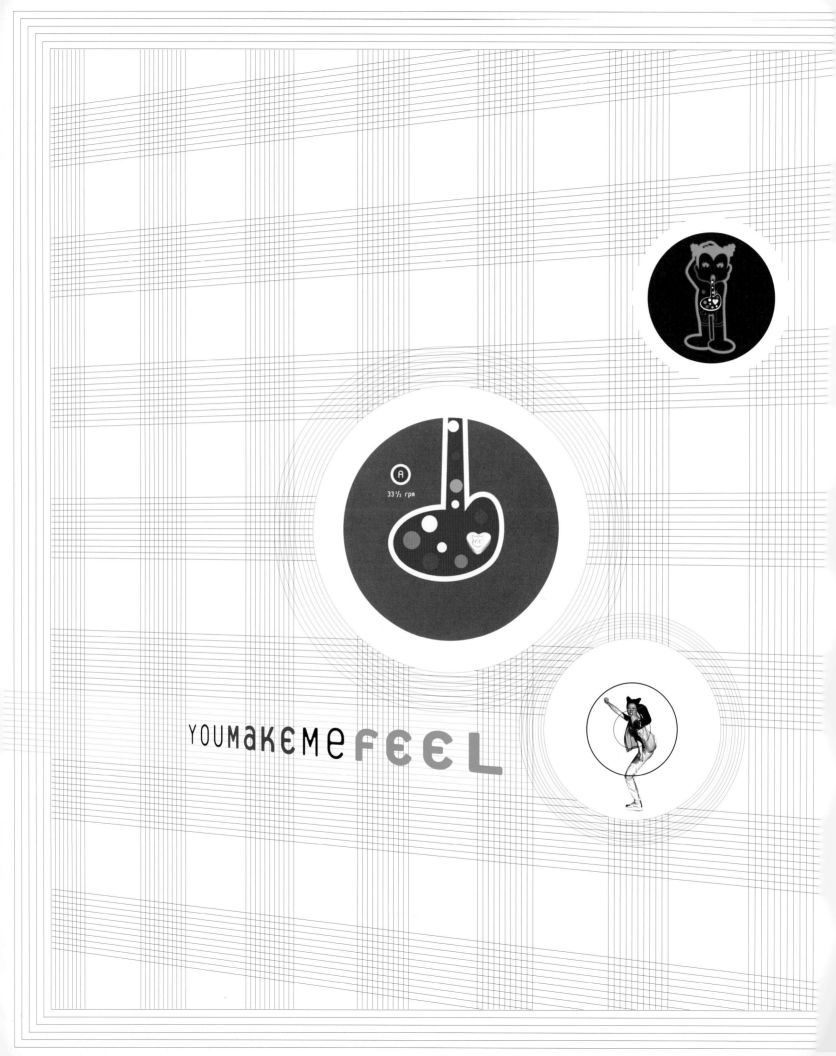

YOUMAKEMEFEEL

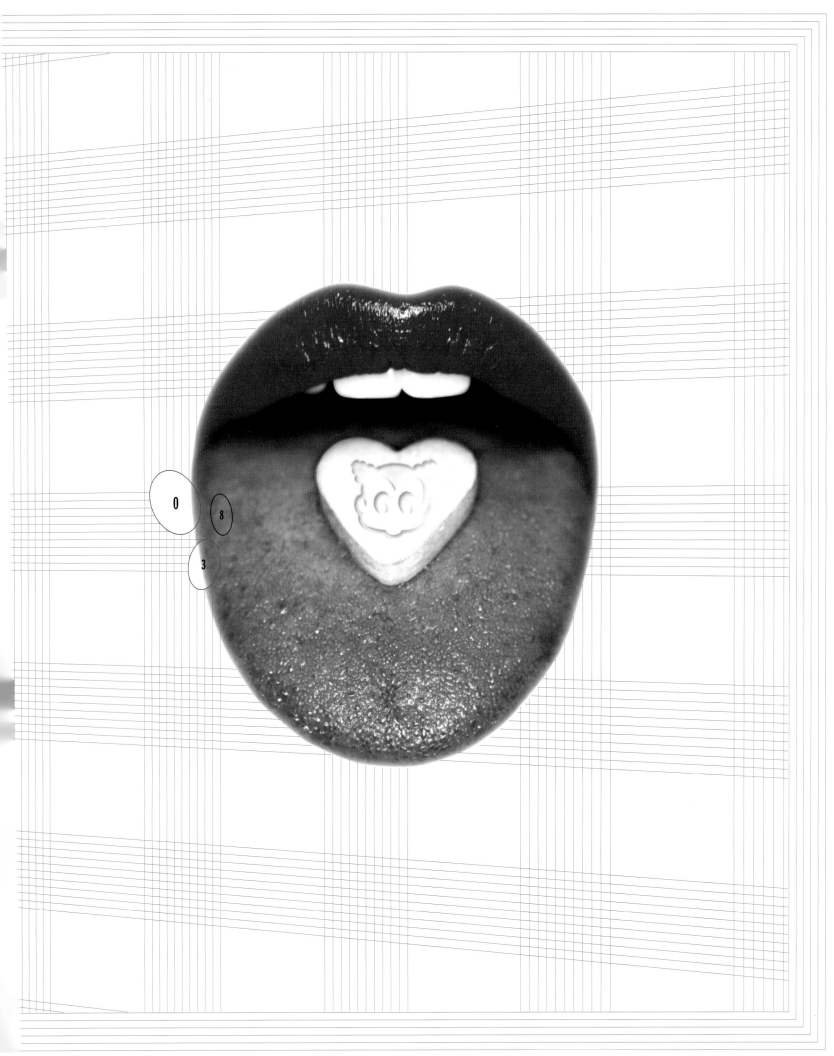

funky BEES

TRACK 1
EIFERSUCHT

TRACK 2 NICHT
ANERKANNT

...nky | BEES

...ERSUCHT 2 NICHT ANERKANNT

promo

cd

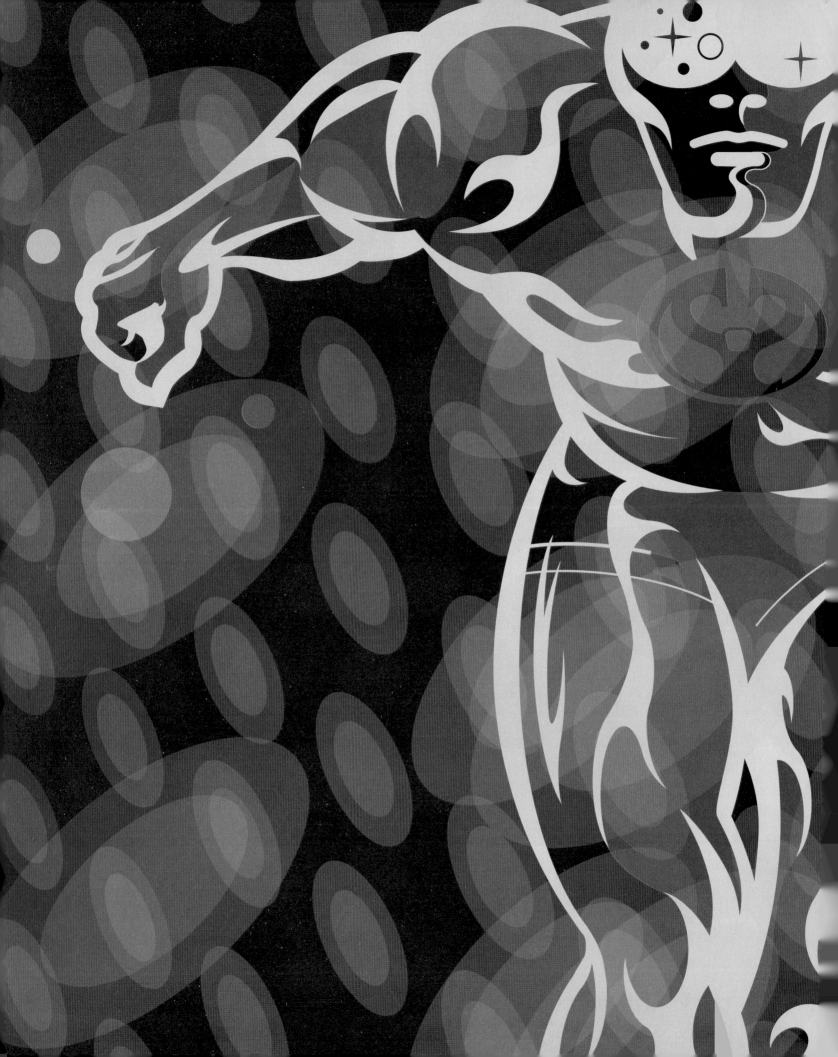

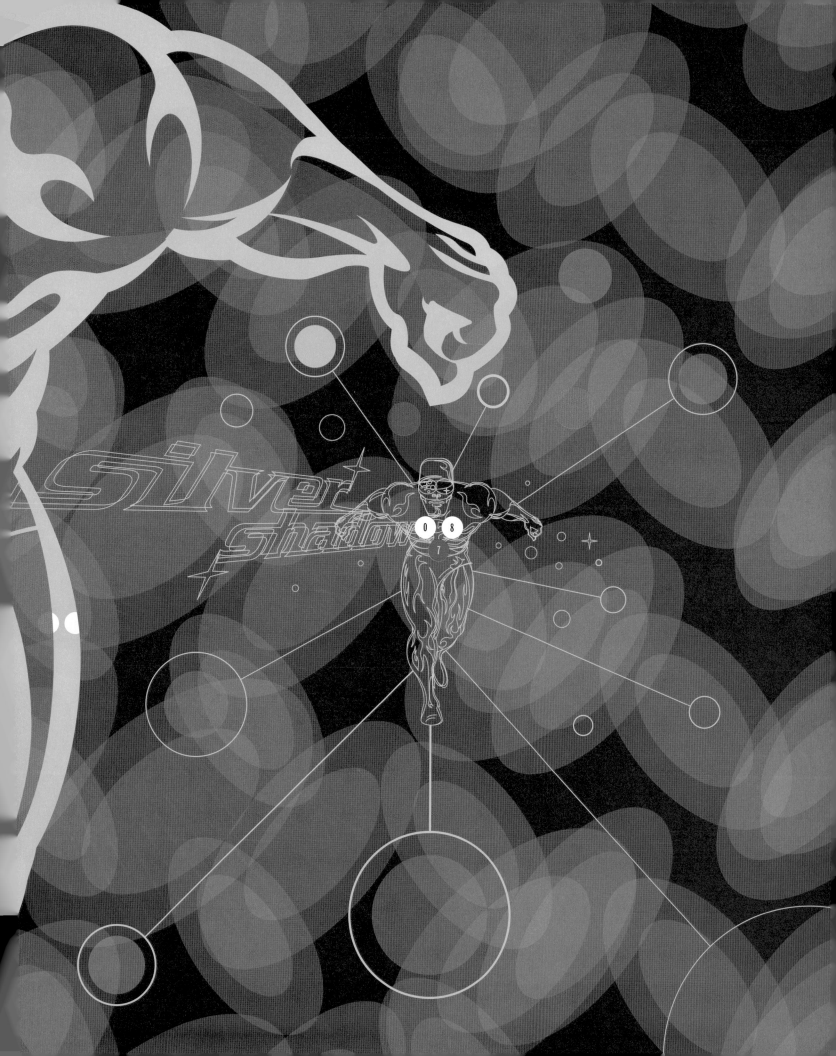

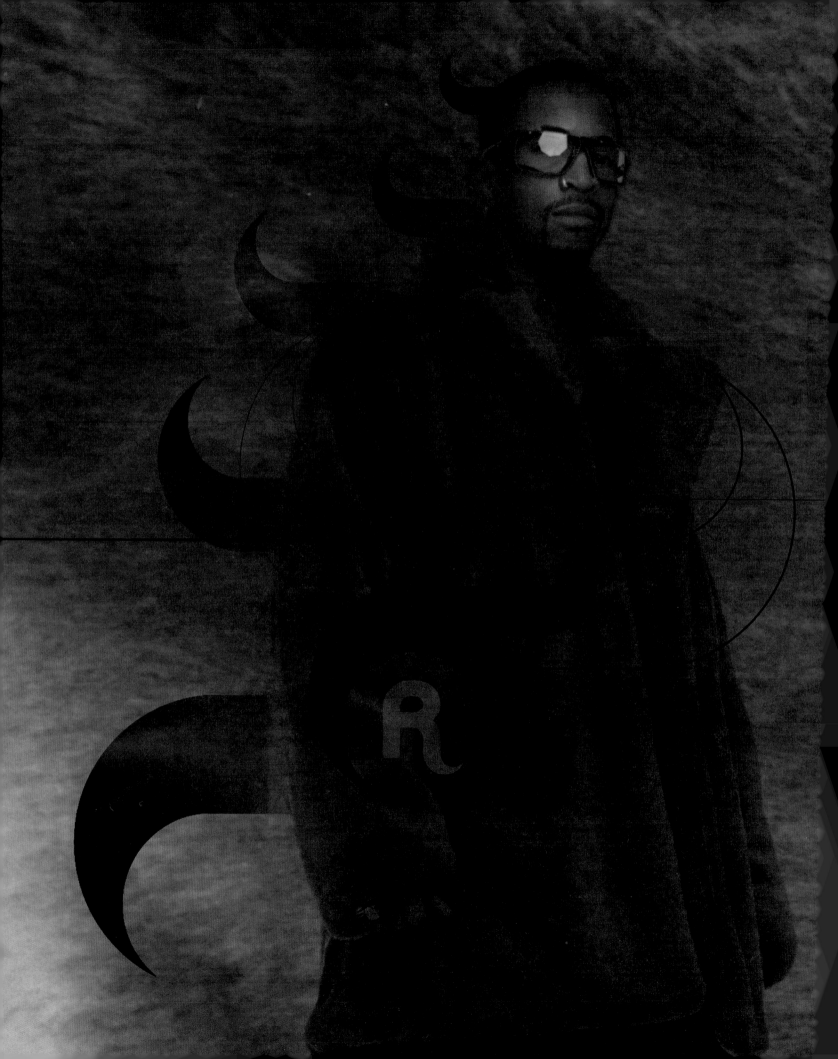

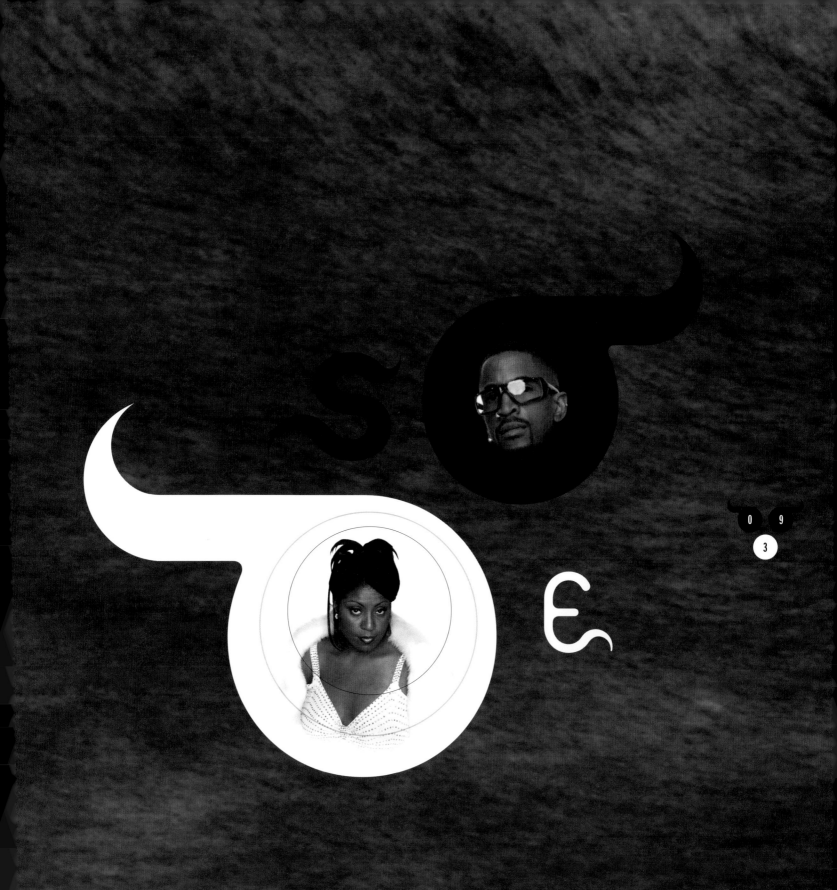

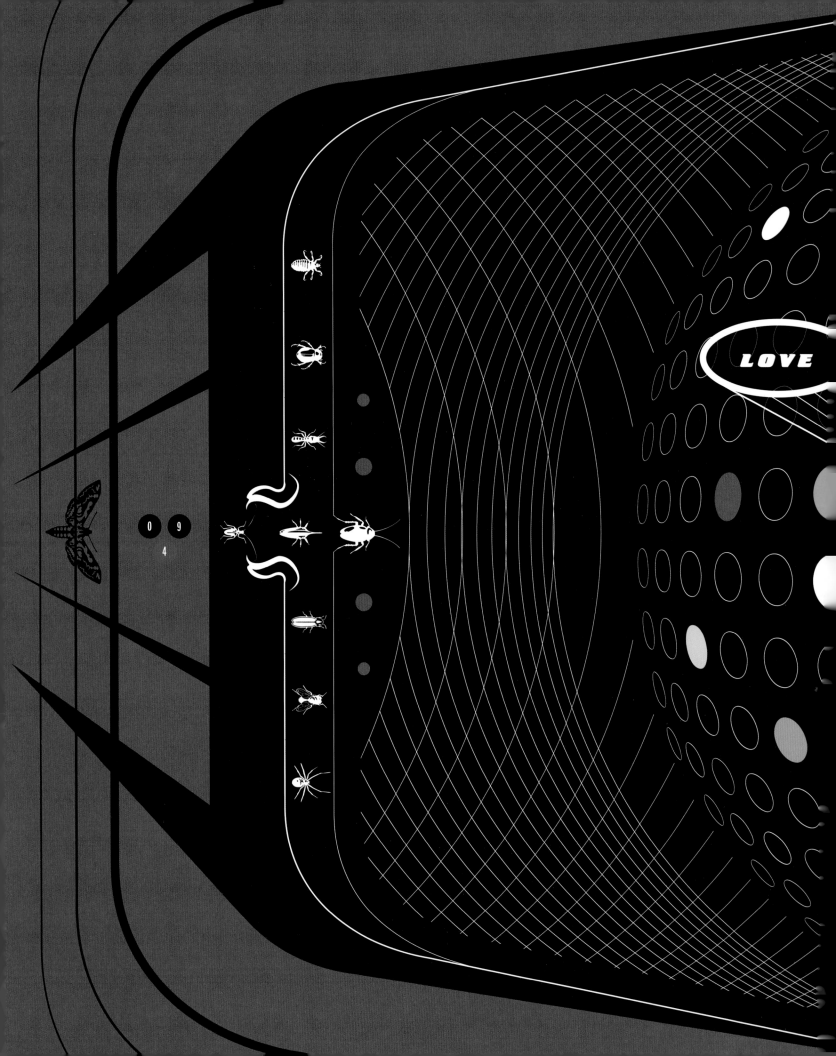

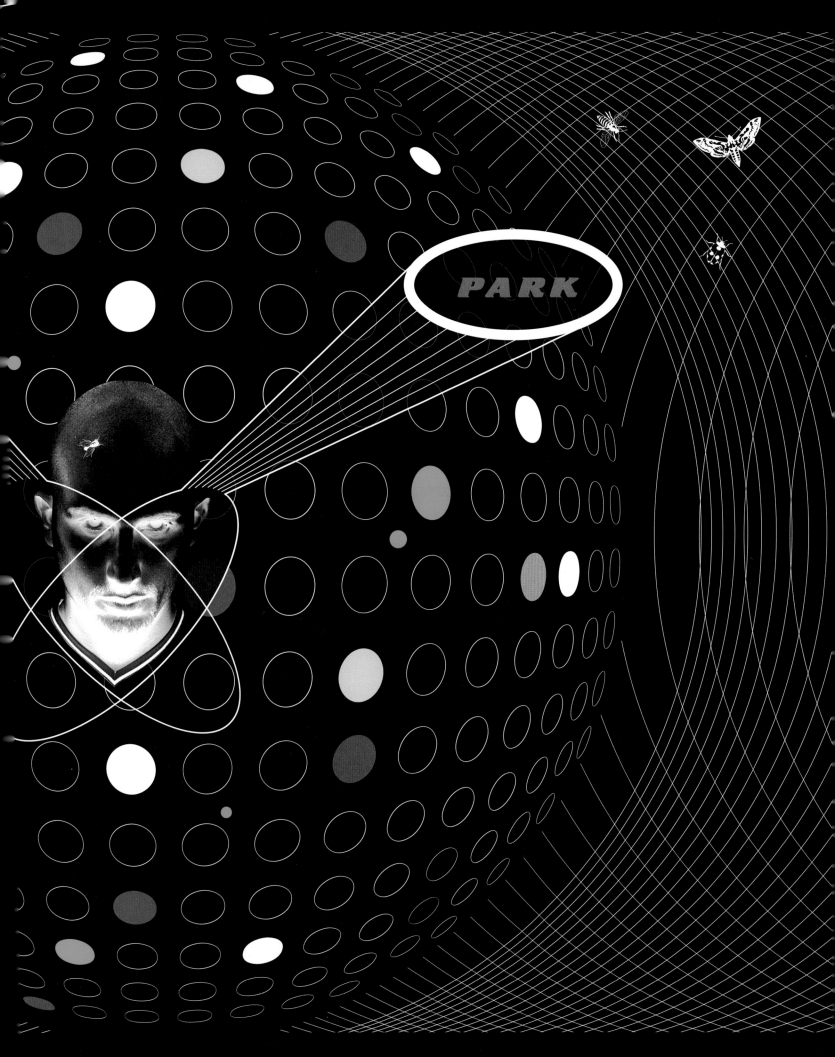

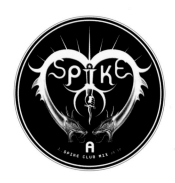

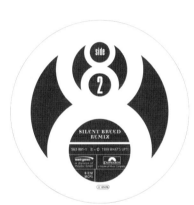

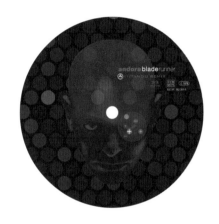

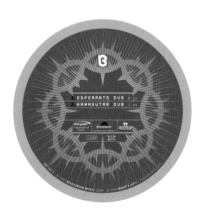

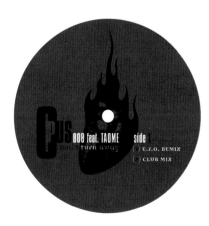

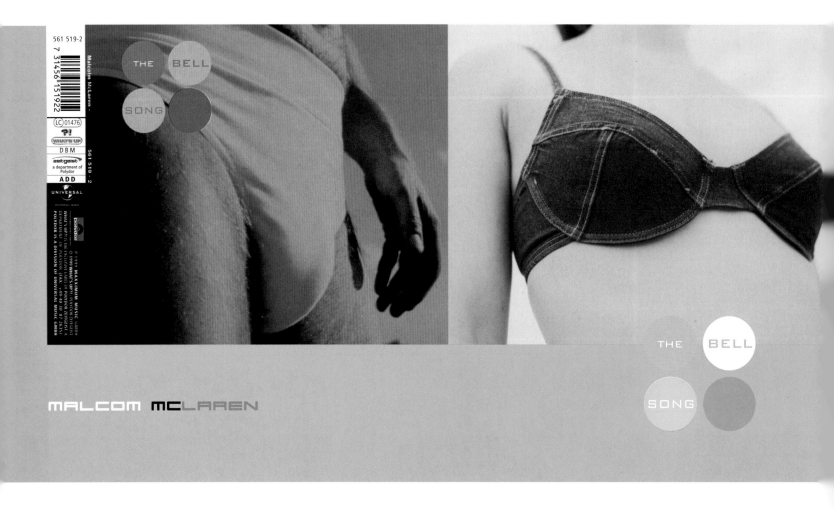

561 519-2

7 31456 151922

Malcom McLaren -

(LC) 01476

?!
WHAT'S UP

D B M

zeitgeist
a department of
Polydor

ADD

UNIVERSAL

Polydor

561 519 - 2

Ⓟ 1999 MAXXIMUM MUSIC GMBH
WHAT'S UP?! IS THE EXCLUSIVE LABEL OF POLYDOR ZEITGEIST.
© 1999 WHAT'S UP?! POLYDOR ZEITGEIST.
DEPARTMENT OF POLYDOR (FAX: +49 40 10 87 2835)
POLYDOR IS A DIVISION OF UNIVERSAL MUSIC GMBH

THE BELL

SONG

THE BELL

SONG

MALCOM MCLAREN

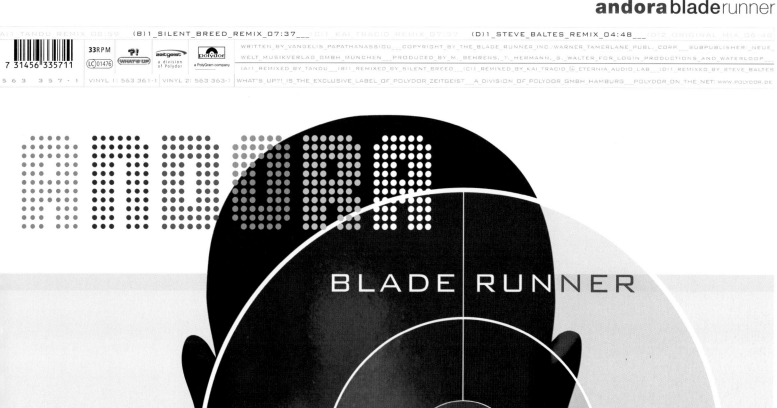

andora **blade**runner

A/1 TANDU REMIX 08:59 (B)1_SILENT_BREED_REMIX_07:37___ (C)1 KAI TRACID REMIX 07:37 (D)1_STEVE_BALTES_REMIX_04:48___ (D)2 ORIGINAL MIX 06:48

7 31456 335711 33RPM ?! zeitgeist polydor WRITTEN BY VANGELIS PAPATHANASSIOU___COPYRIGHT BY THE BLADE RUNNER INC./WARNER TAMERLANE PUBL. CORP___SUBPUBLISHER: NEUE
LC 01476 WHAT'S UP a division a PolyGram company WELT MUSIKVERLAG GMBH MUNCHEN___PRODUCED BY M. BEHRENS, T. HERMANN, S. WALTER FOR LOGIN PRODUCTIONS AND WATERLOOP___
of Polydor (A)1_REMIXED BY TANDU___(B)1 REMIXED BY SILENT BREED___(C)1 REMIXED BY KAI TRACID @ ETERNIA AUDIO LAB___(D)1 REMIXED BY STEVE BALTES
563 357-1 VINYL 1: 563 361-1 VINYL 2: 563 363-1 WHAT'S UP?! IS THE EXCLUSIVE LABEL OF POLYDOR ZEITGEIST___A DIVISION OF POLYDOR GMBH HAMBURG___POLYDOR ON THE NET: WWW.POLYDOR.DE

BLADE RUNNER

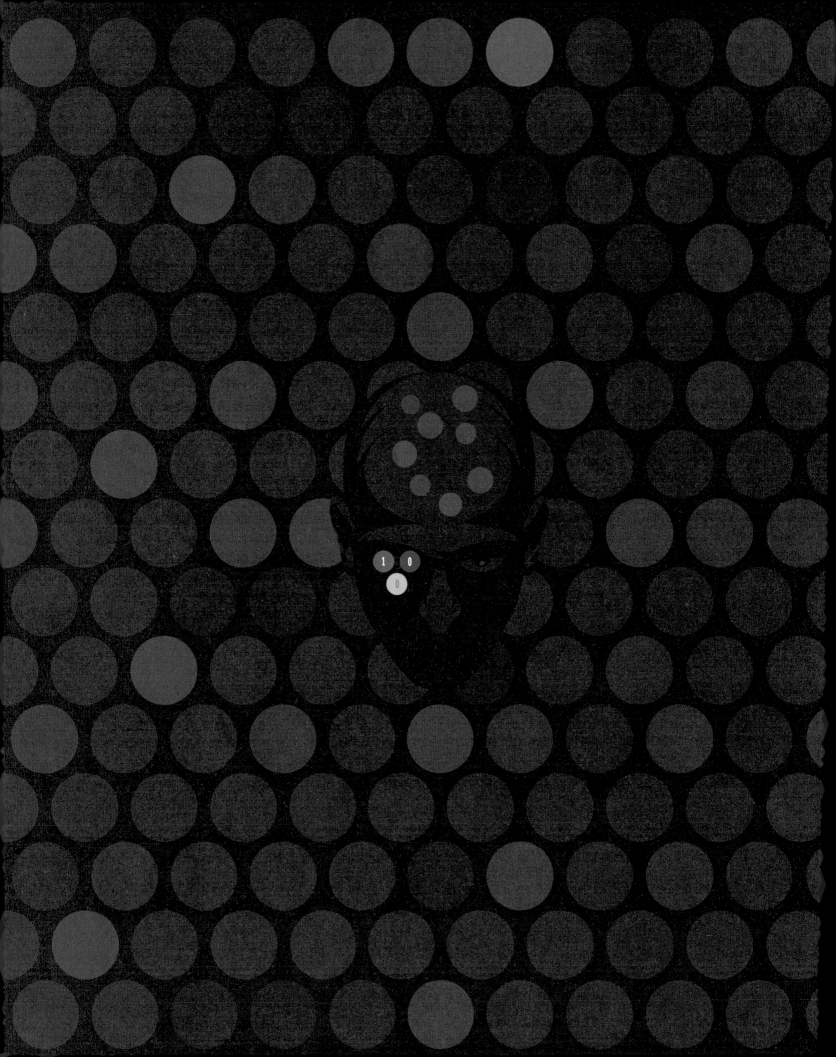

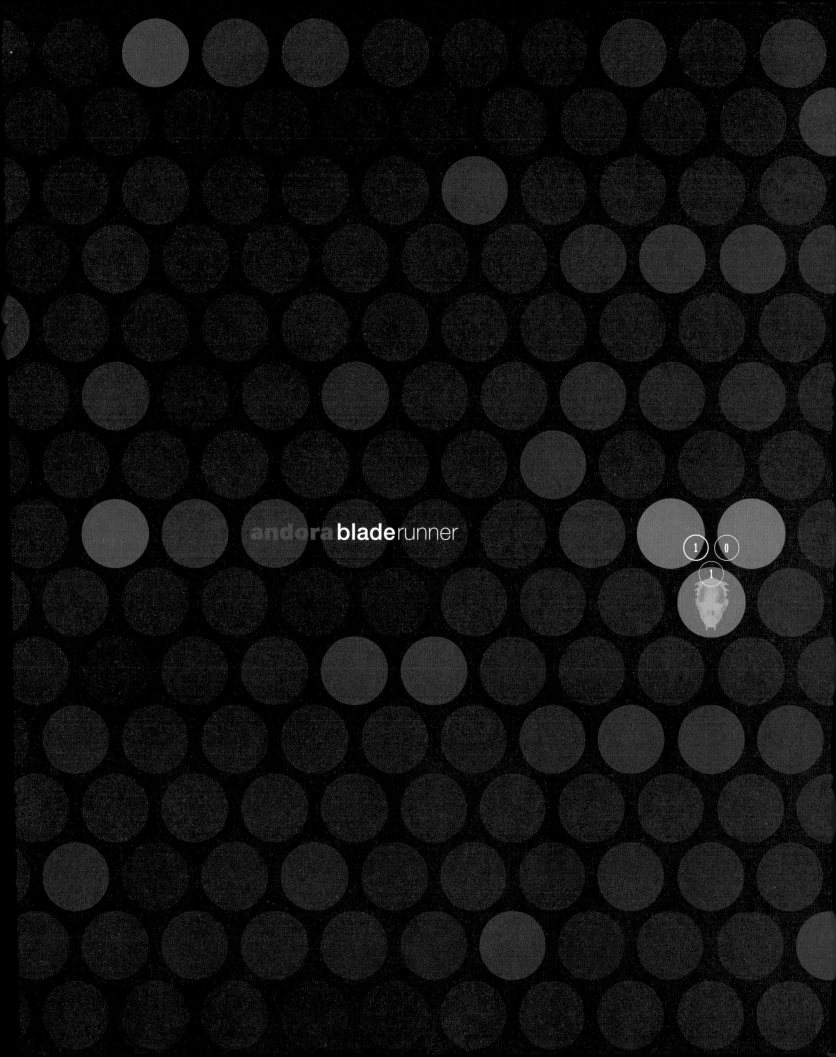

MTV deserves an **Oscar** for coolest customer.

> Motion

Audio 1: I can remember when MTV went on air here in Germany. What a blessing that was.

Corner

1 0

MTV
ON AIR DESIGN 1999

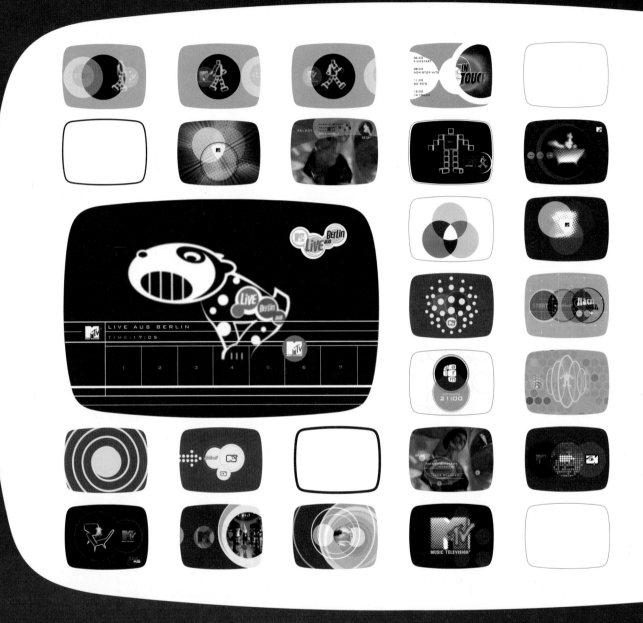

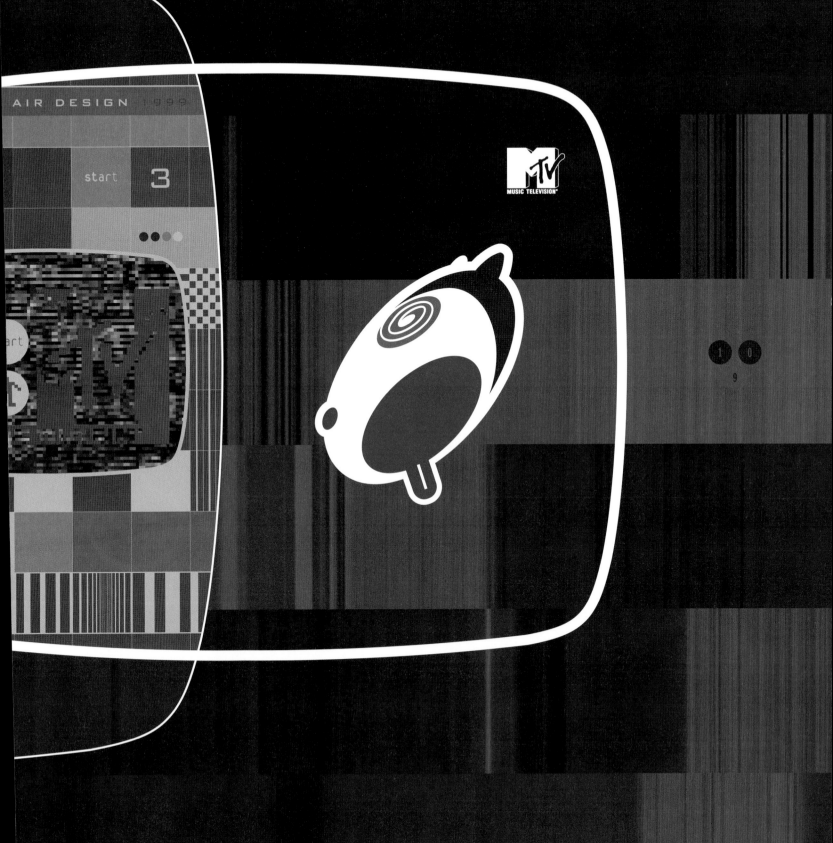

start

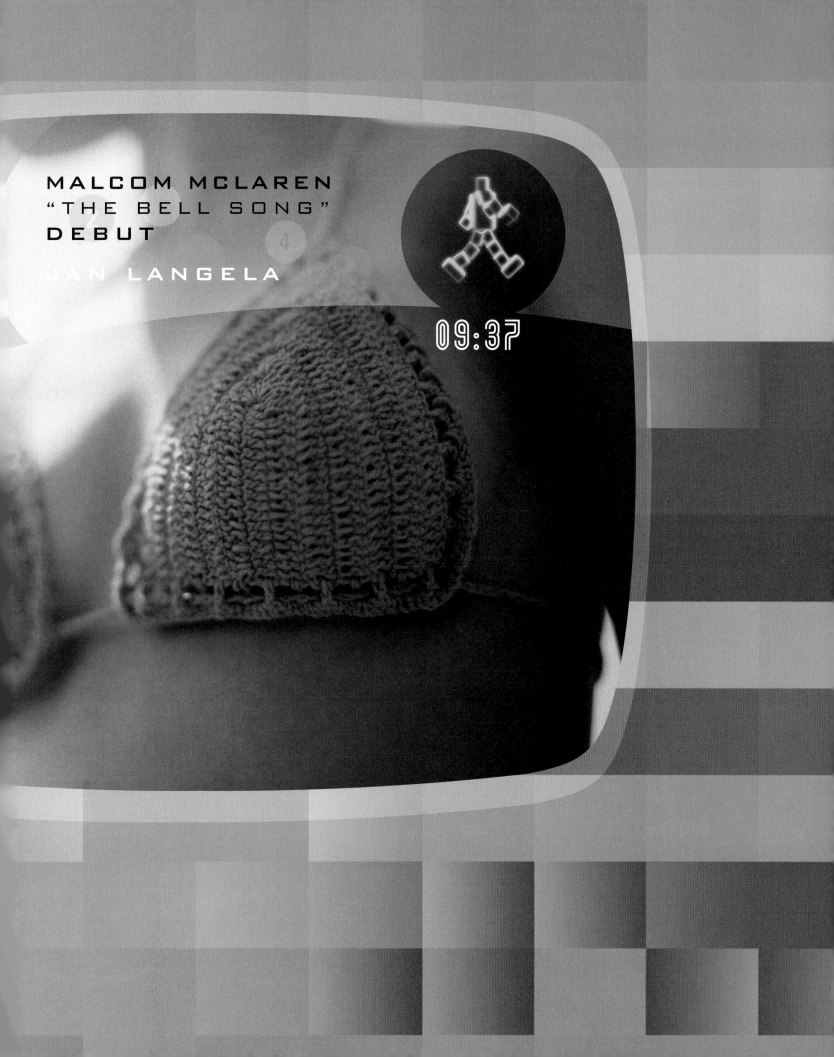

MALCOM MCLAREN
"THE BELL SONG"
DEBUT

JAN LANGELA

09:37

Nacht Lager

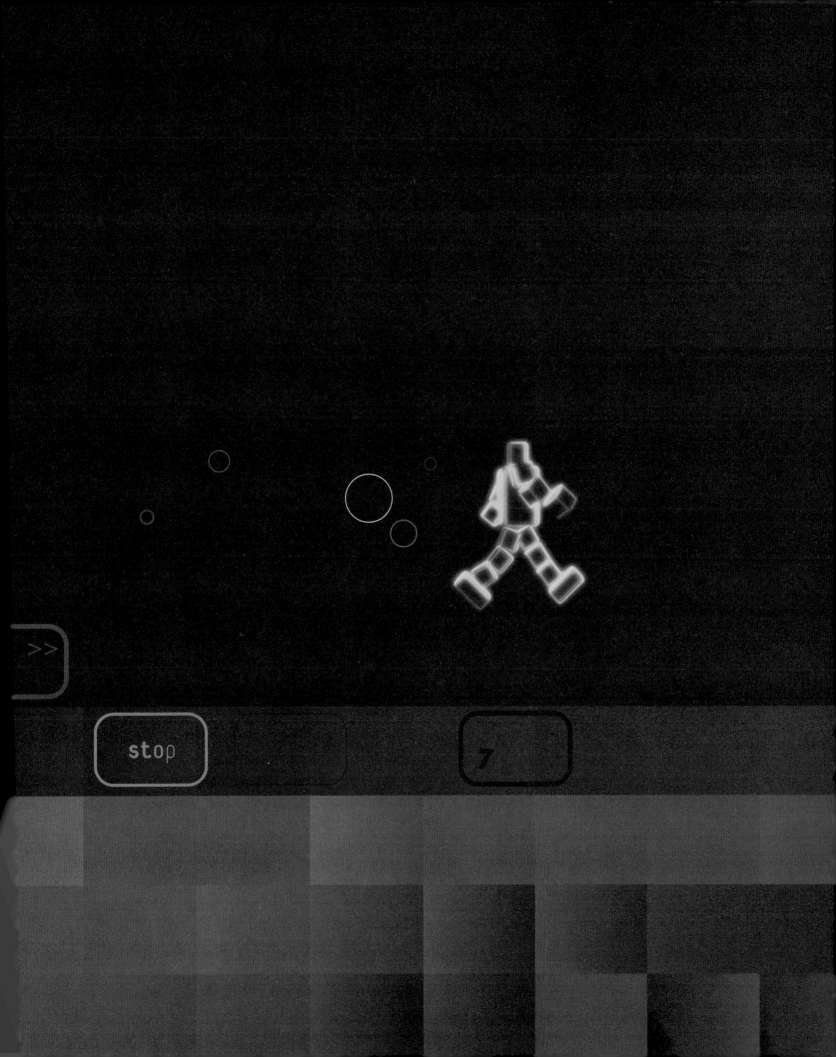

Audio 1: Hello. I think a Swatch watch ... from to show the time ... Audio 2 ... can ... we don't ... easy at the moment.

Audio 1: Well? For example: ... steel watches with an animated LCD doggy on the display ...

... develop our own "special model" really ... look at it ... charming little doggy ...

Audio 1: It's a Swatch then? What ... it ... be a ... SWATCHdog ...

... ... for Swatch ... design a little dog in different positions ... the actual animation effect ... the LCD came later ...

Audio 2: For a minute I thought you were going to ask: "Does SWATCHdog ... was a real creature to the LCD part. In order to realize it, the dog had to be really ... simple. Yet it had to be ... active and ticking. And it was pretty difficult to do both. To generate enough ... emotion ... always showed the full face, no matter ... what position at a dog from the side has no effect at all.

Audio 1: Simple is always the most difficult thing.

"Beat"

Sample: Little rascal on the display

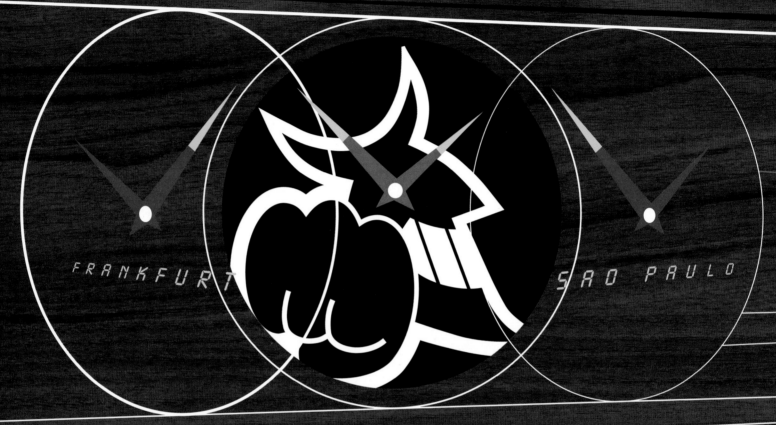

FRANKFURT SAO PAULO

Sample: Dog from the side has no effect.

Audio 2: I drafted tons of scribbles ...

Audio 1: By hand? How analogue can you get?

Audio 2: Well, of course it's possible to create those figures on the computer. Technically speaking, that isn't a problem for me, but the results always turn ... gradually develop a good drawing. I then scan them into the computer and ...

... process the outlines ...

Audio 1: So you also did all the details for two SWATCH watches ...

Audio 2: Yes, most watches. Valentine Swatch you get a watch on St. Valentine's Day ...

Audio 1: How charming! ...

Audio 2: We really put a lot of work into ... "Love and Partnership". It's a pretty big subject. Unfortunately our customer was irritated with some ... Naturally, obviously, the most daring designs were not realized.

Audio 1: You called the watches "Sheep" and "Space Sheep".

Audio 2: That's ... Well, decent SWATCH watches are supposed to be called ...

Audio 1: What was originally your favourite design?

Audio 2: I went for the devil design. It's not the slightest bit romantic, but I think that's what I really like about the idea.

... ... the slightest bit romantic.

Sample: Devils

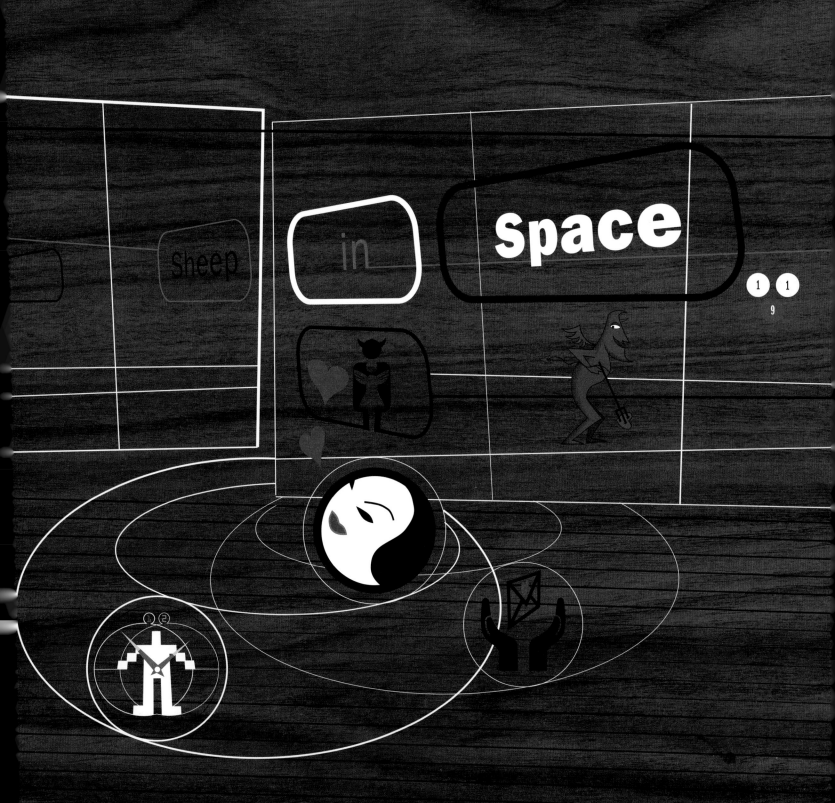

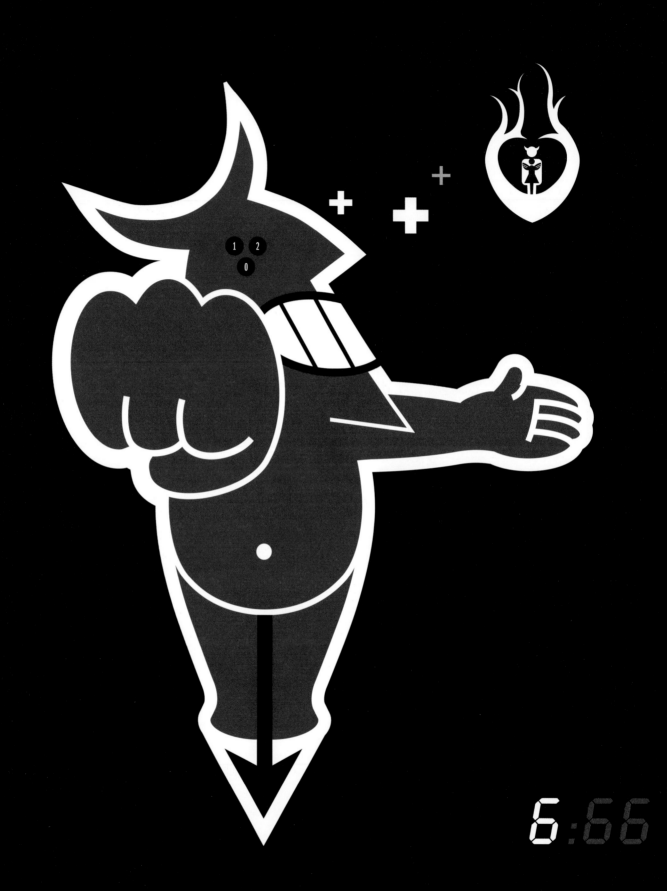

6:66

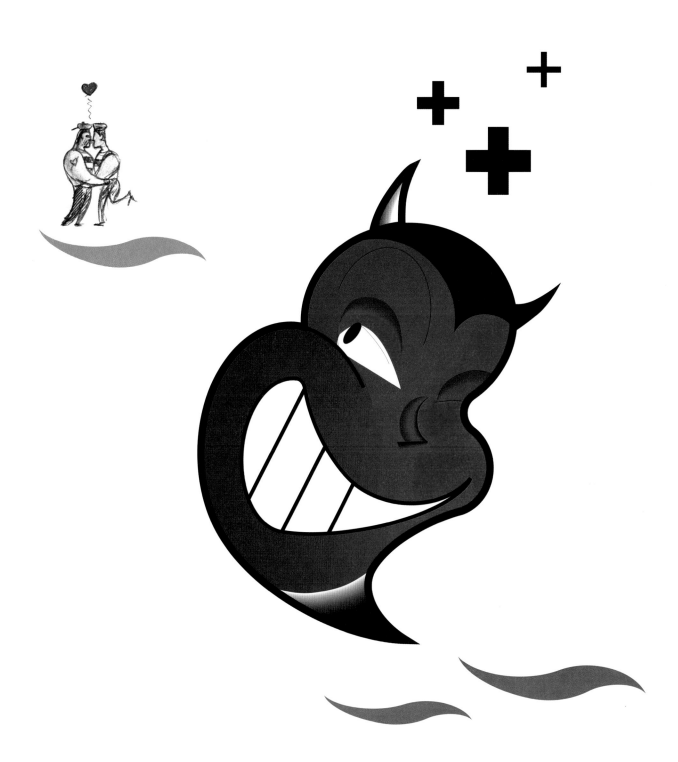

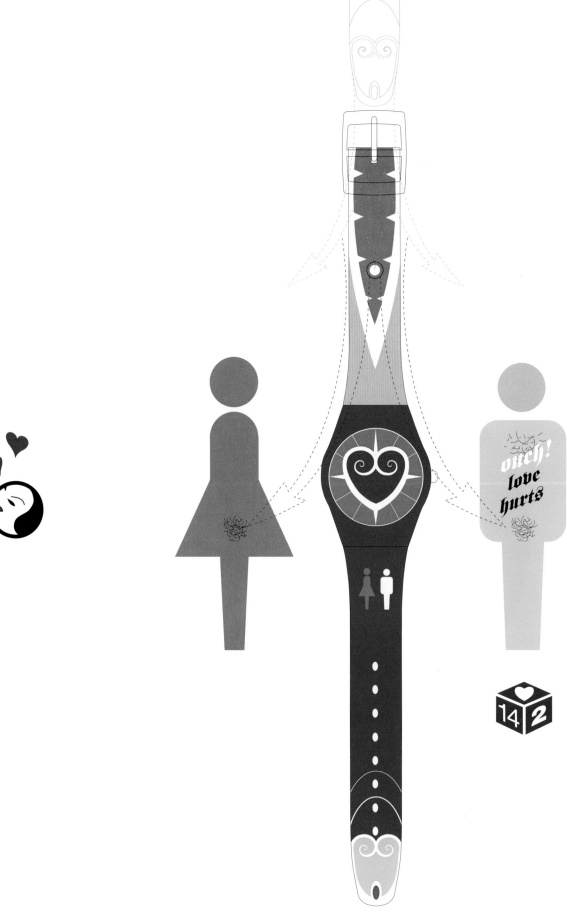
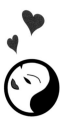

ouch!
love
hurts

14 2

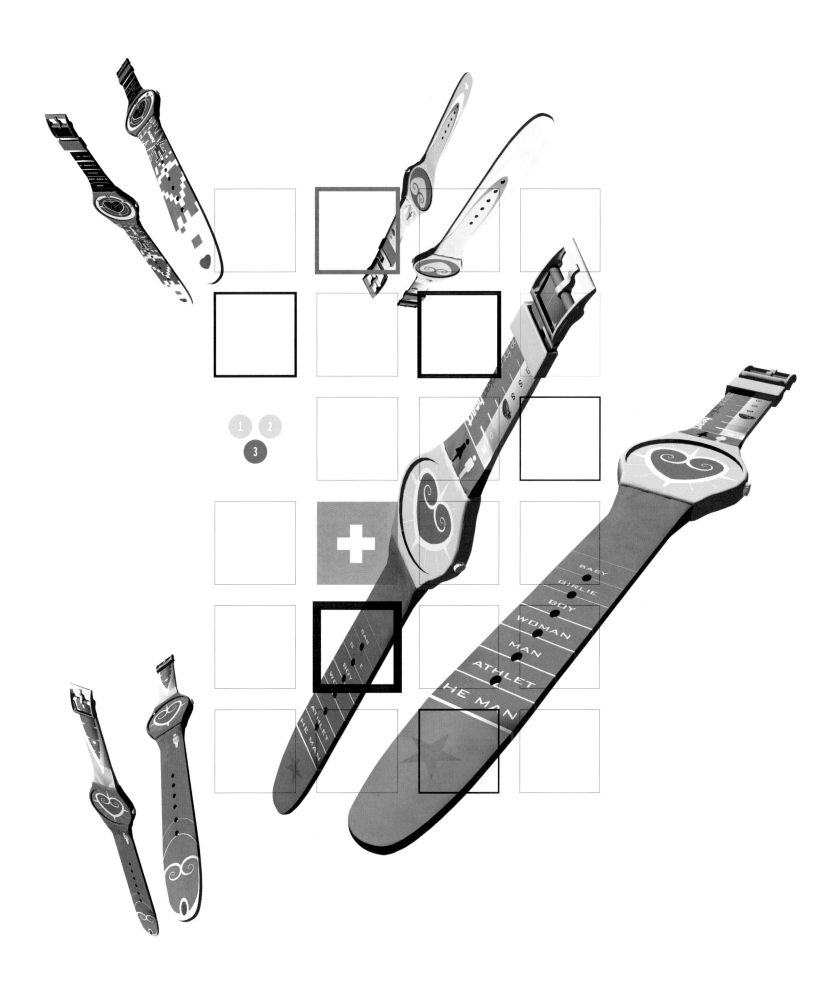

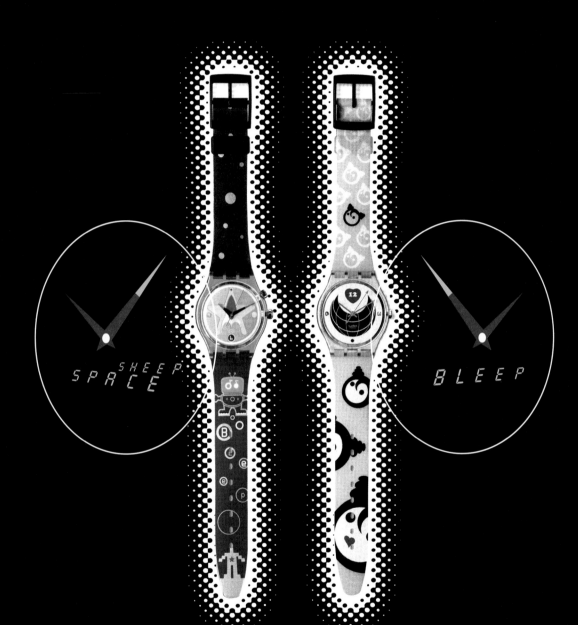

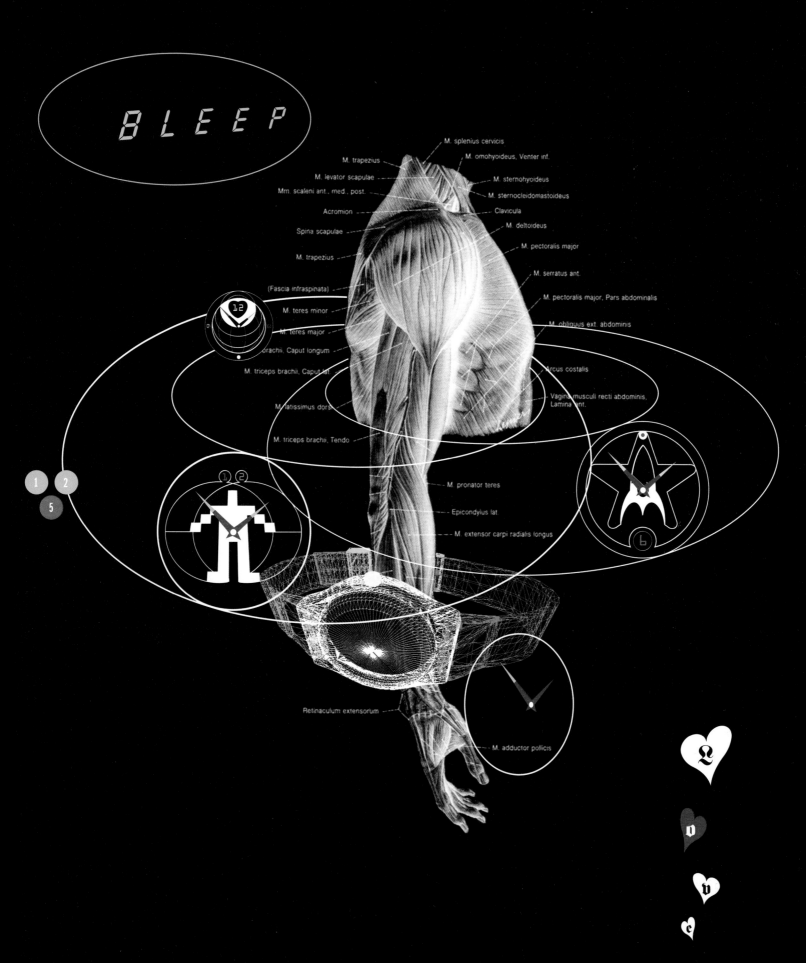

BLEEP

M. splenius cervicis
M. omohyoideus, Venter inf.
M. trapezius
M. sternohyoideus
M. levator scapulae
M. sternocleidomastoideus
Mm. scaleni ant., med., post.
Clavicula
Acromion
M. deltoideus
Spina scapulae
M. pectoralis major
M. trapezius
M. serratus ant.
(Fascia infraspinata)
M. pectoralis major, Pars abdominalis
M. teres minor
M. obliquus ext. abdominis
M. teres major
brachii, Caput longum
M. triceps brachii, Caput lat.
Arcus costalis
M. latissimus dors.
Vagina musculi recti abdominis, Lamina ant.
M. triceps brachii, Tendo
M. pronator teres
Epicondylus lat.
M. extensor carpi radialis longus
Retinaculum extensorum
M. adductor pollicis

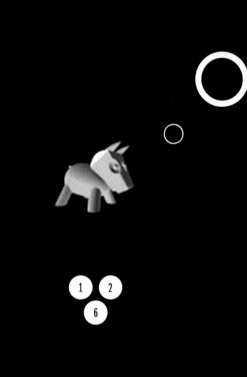

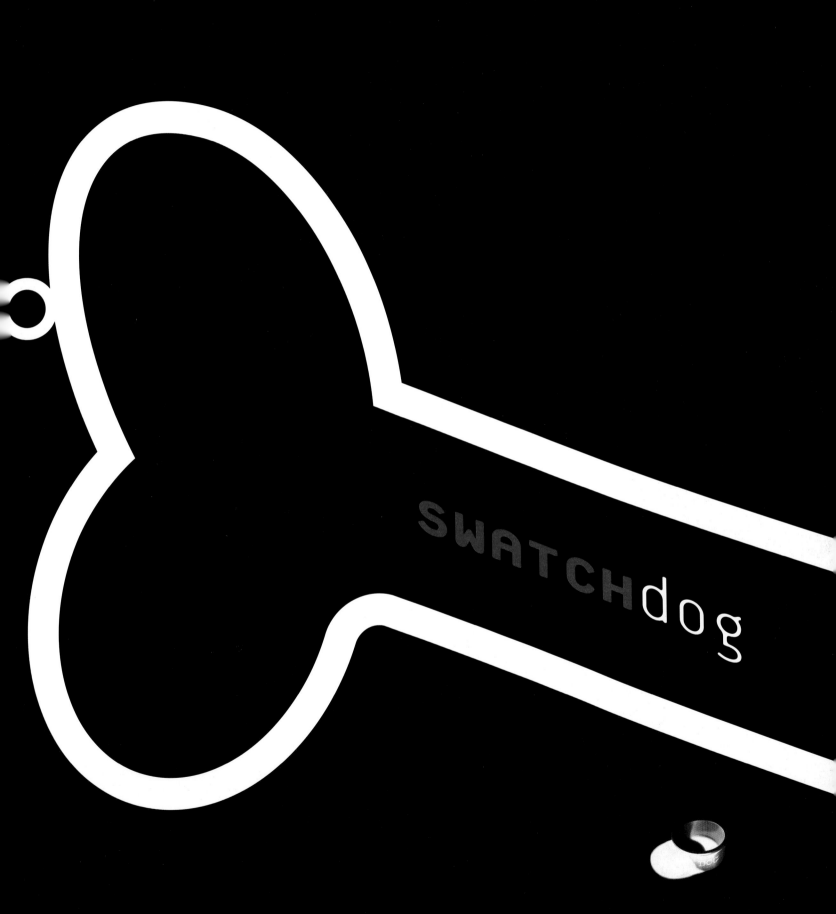

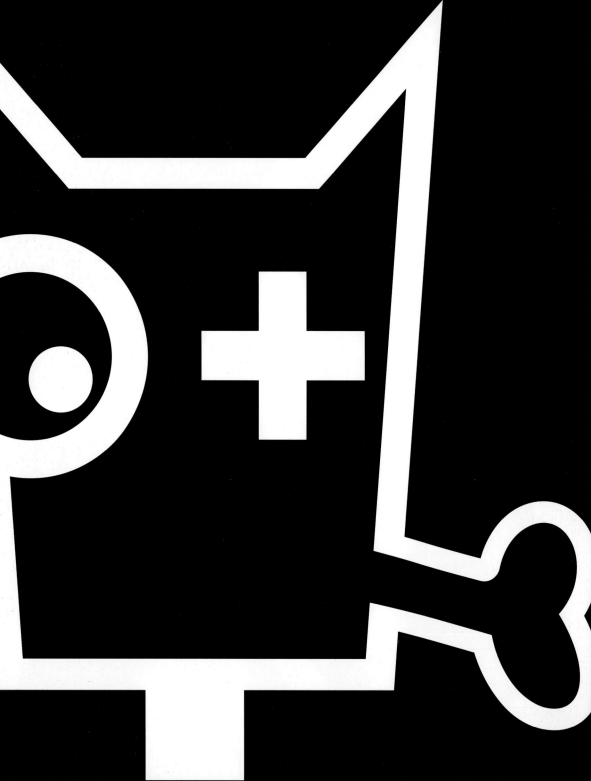

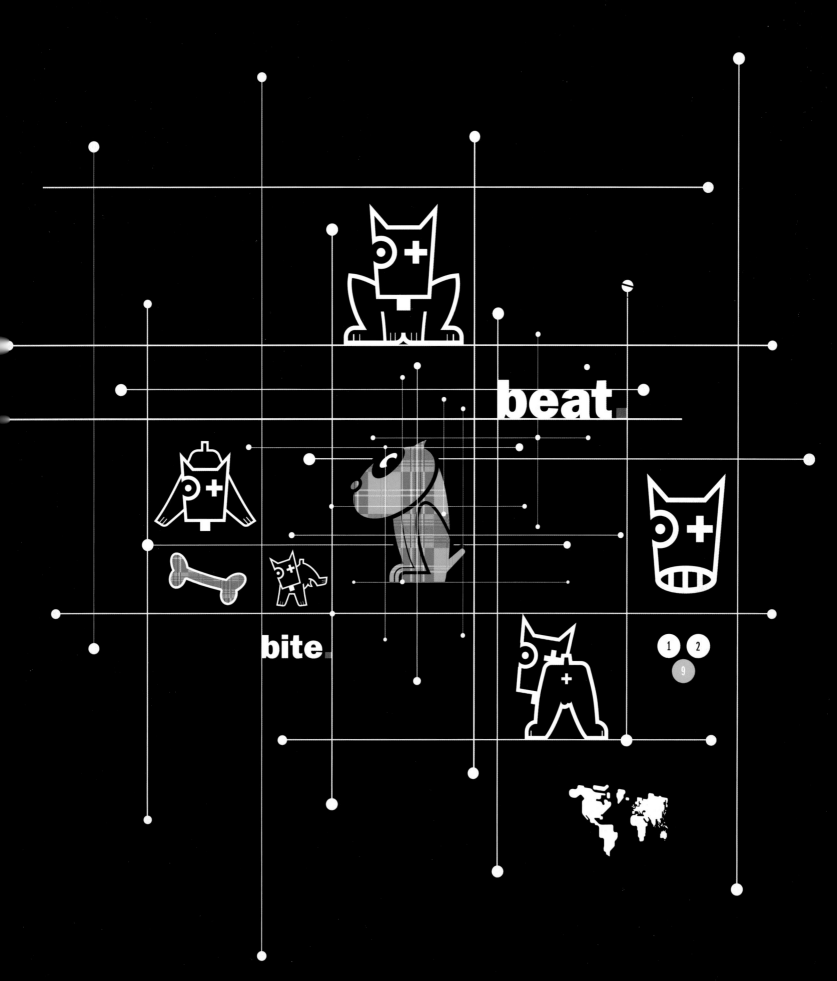

beat.

bite.

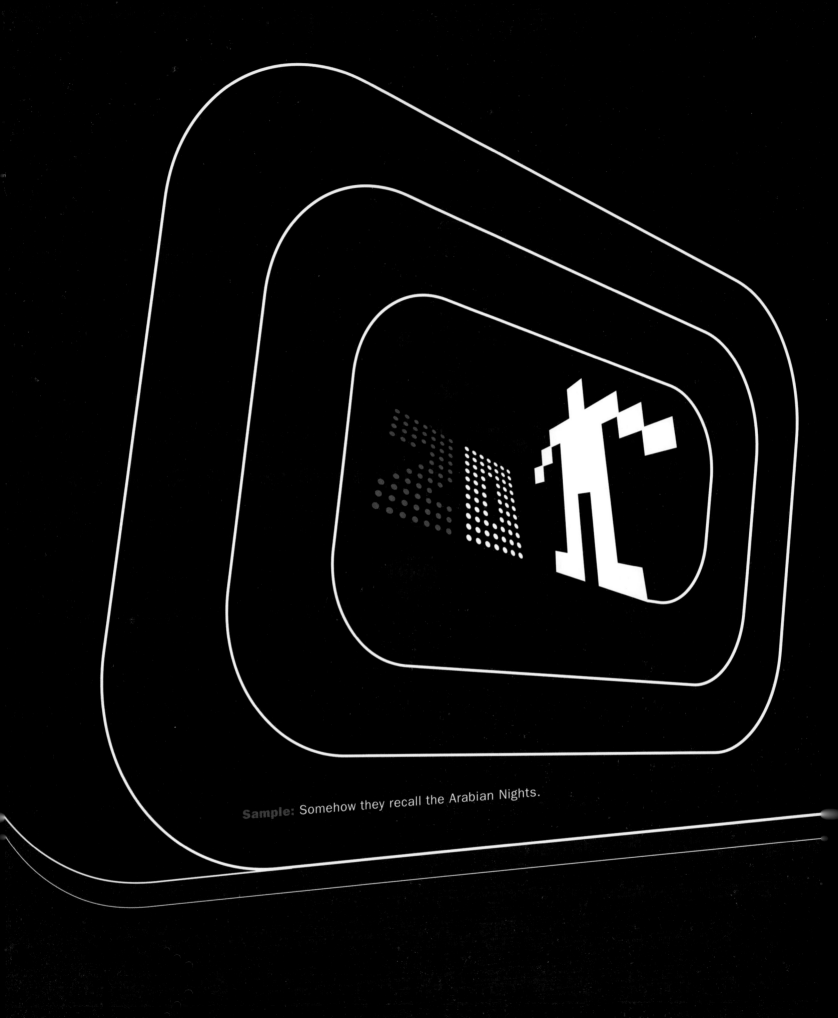

Sample: Somehow they recall the Arabian Nights.

Form

and **Flesh**

F

Rhythmus

HIG

17

HIGHLIGHT | ENHAN

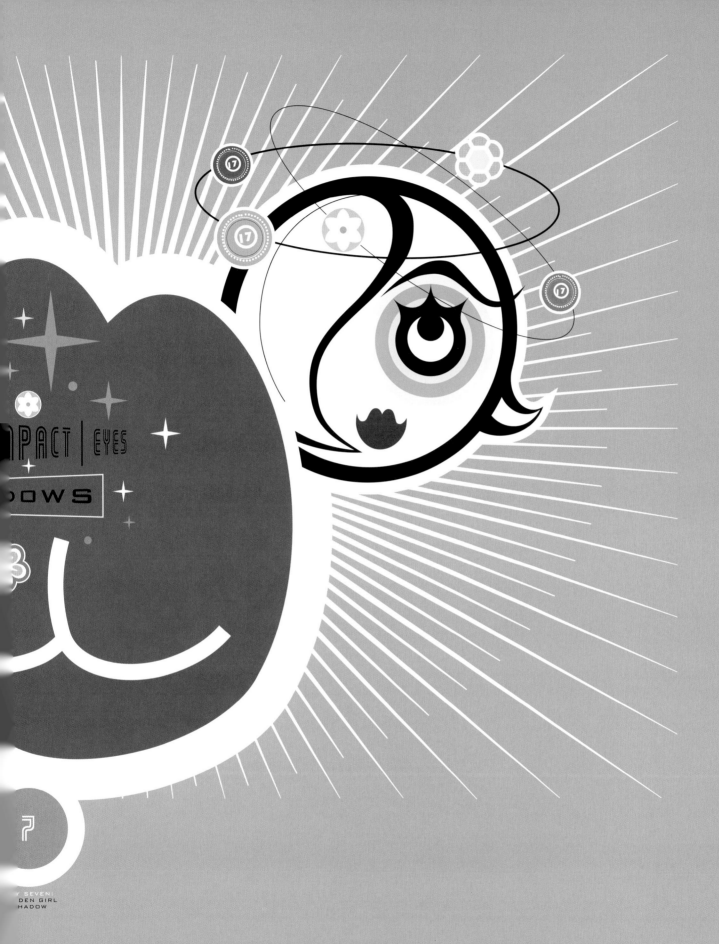

PACT | EYES

OWS

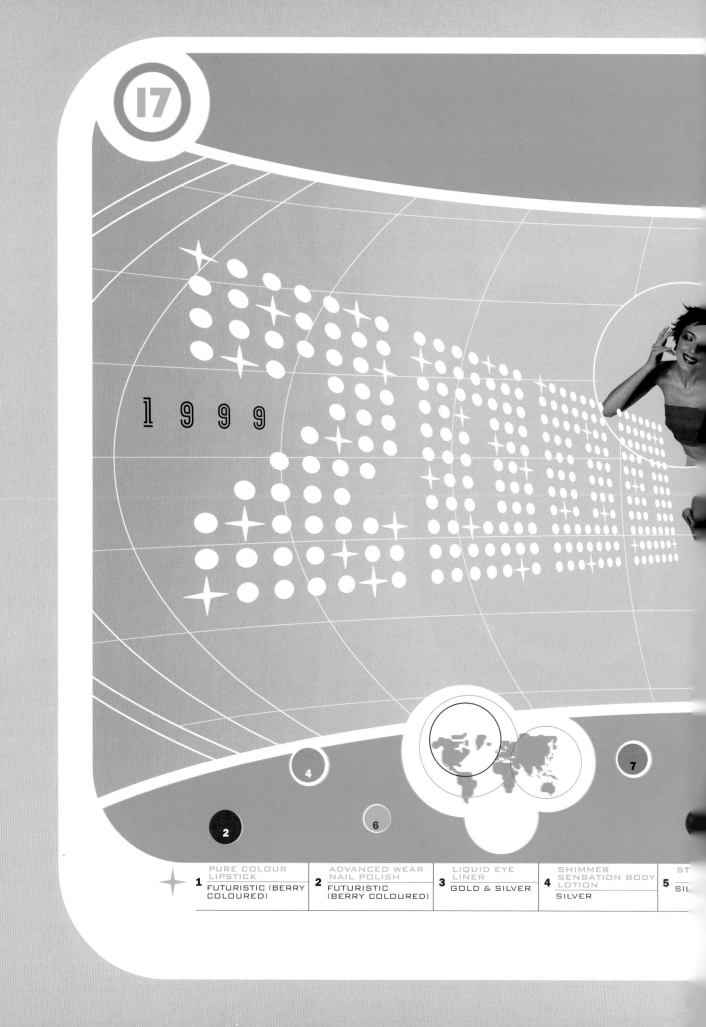

1 9 9 9

	PURE COLOUR LIPSTICK		ADVANCED WEAR NAIL POLISH		LIQUID EYE LINER		SHIMMER SENSATION BODY LOTION		ST
1	FUTURISTIC (BERRY COLOURED)	2	FUTURISTIC (BERRY COLOURED)	3	GOLD & SILVER	4	SILVER	5	SIL

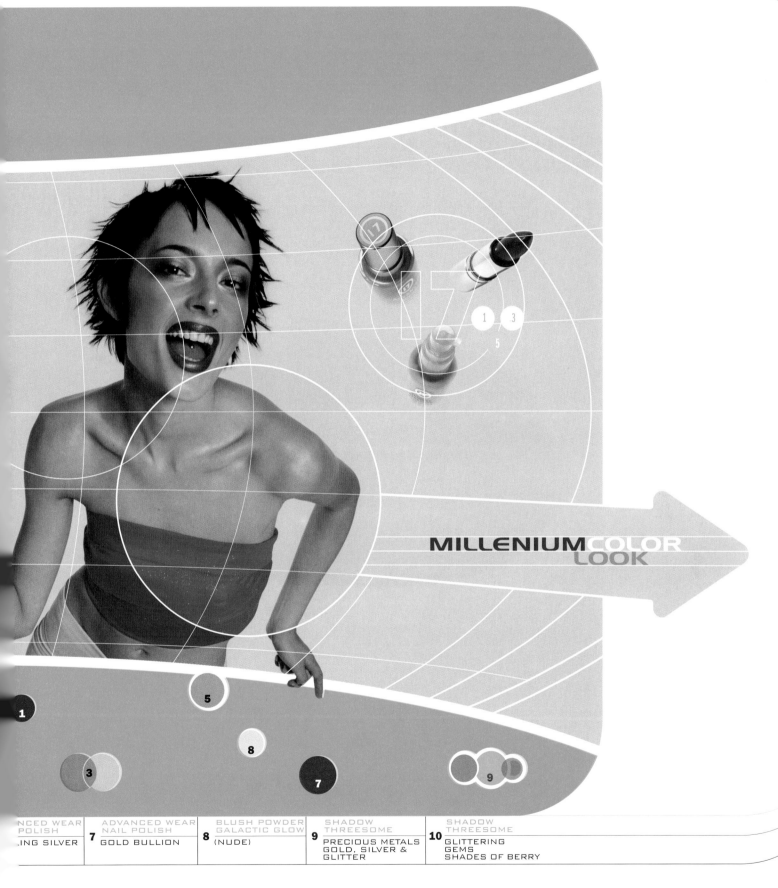

MILLENIUM COLOR LOOK

NCED WEAR POLISH	7	ADVANCED WEAR NAIL POLISH	8	BLUSH POWDER GALACTIC GLOW	9	SHADOW THREESOME	10	SHADOW THREESOME
ING SILVER		GOLD BULLION		(NUDE)		PRECIOUS METALS GOLD, SILVER & GLITTER		GLITTERING GEMS SHADES OF BERRY

LLENIUM COLOUR LOOK LIMITED EDITION SILVER PACKS

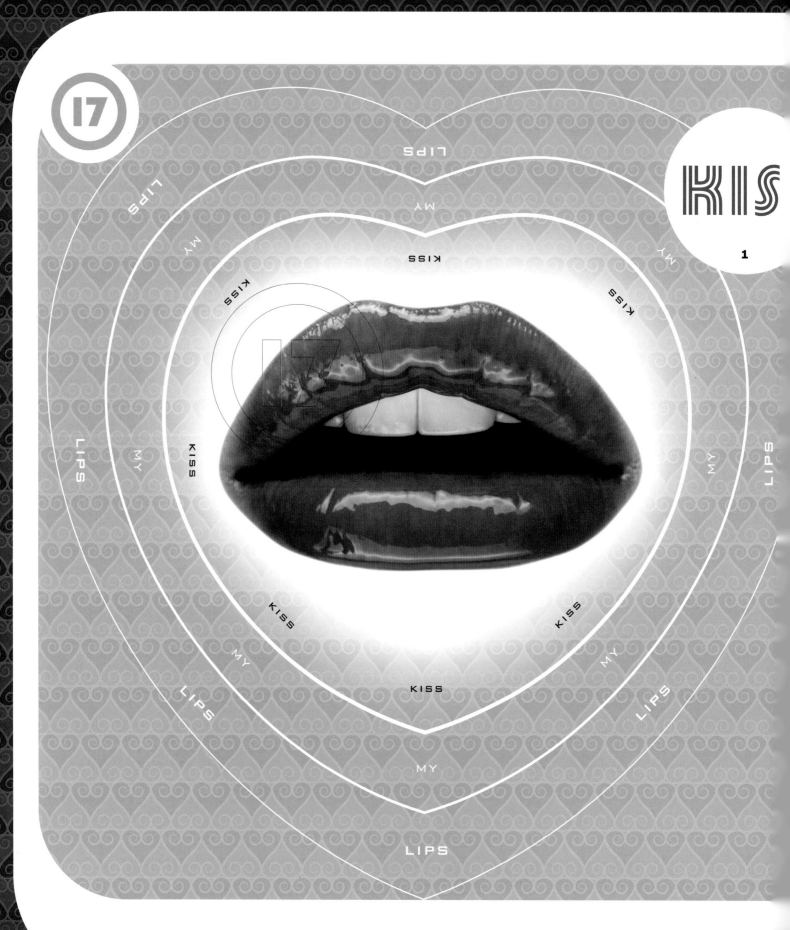

LIPS

Y

3

1 3

7

PLUMP=UP

THE VOLUME LIPSHINE

HIGH GLOSS,
SENSUAL,
MORE KISSABLE LIPS

		1	2	3
		LIP SHINE LIPSTICK	LIP SHINE LIPSTICK	LIP SHINE LIPSTICK
		IN THE NUDE	BARELY PINK	CRYSTAL

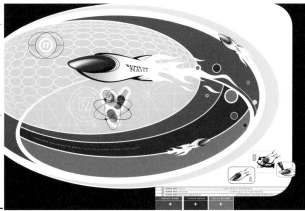

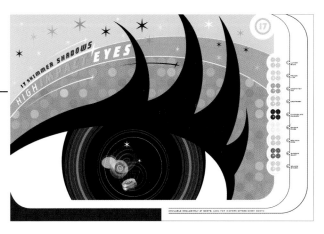

de**form**ed

:**SHOPPING**
2/2000

27 DM / sFr / 210 ÖS
D**3442**

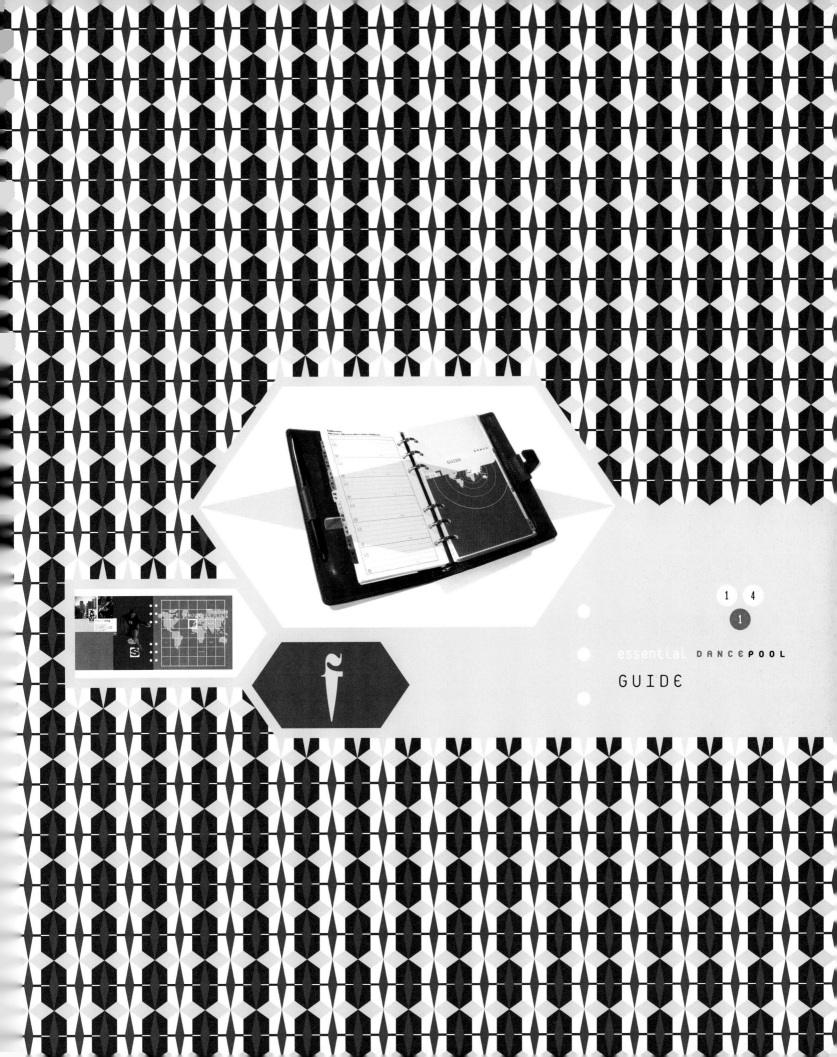

essential DANCEPOOL

GUIDE

1 4
1

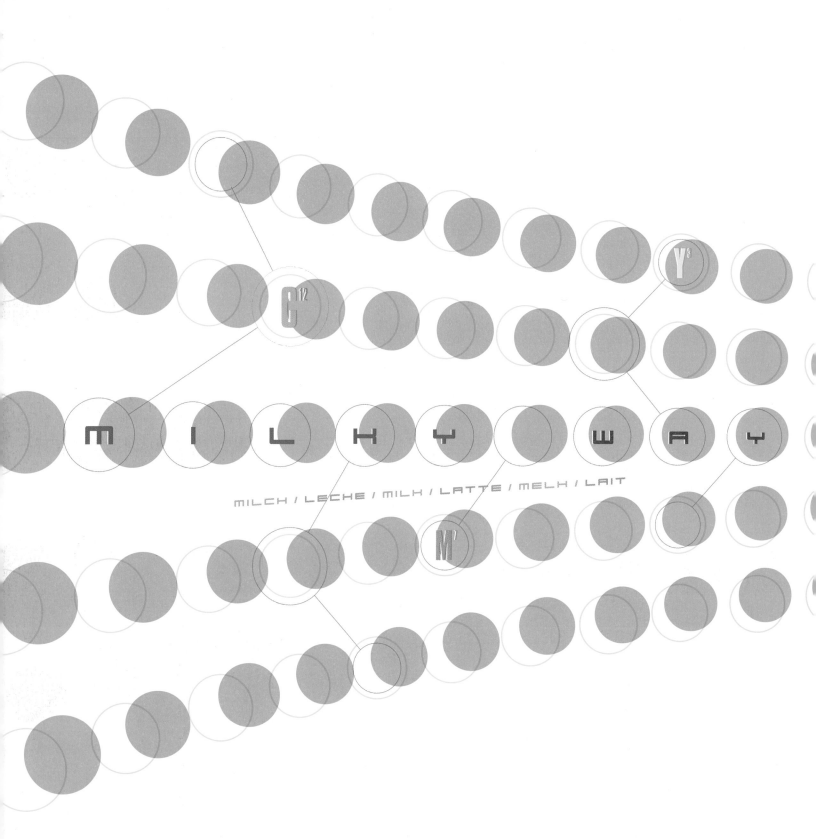

MILKY WAY

MILCH / LECHE / MILK / LATTE / MELK / LAIT

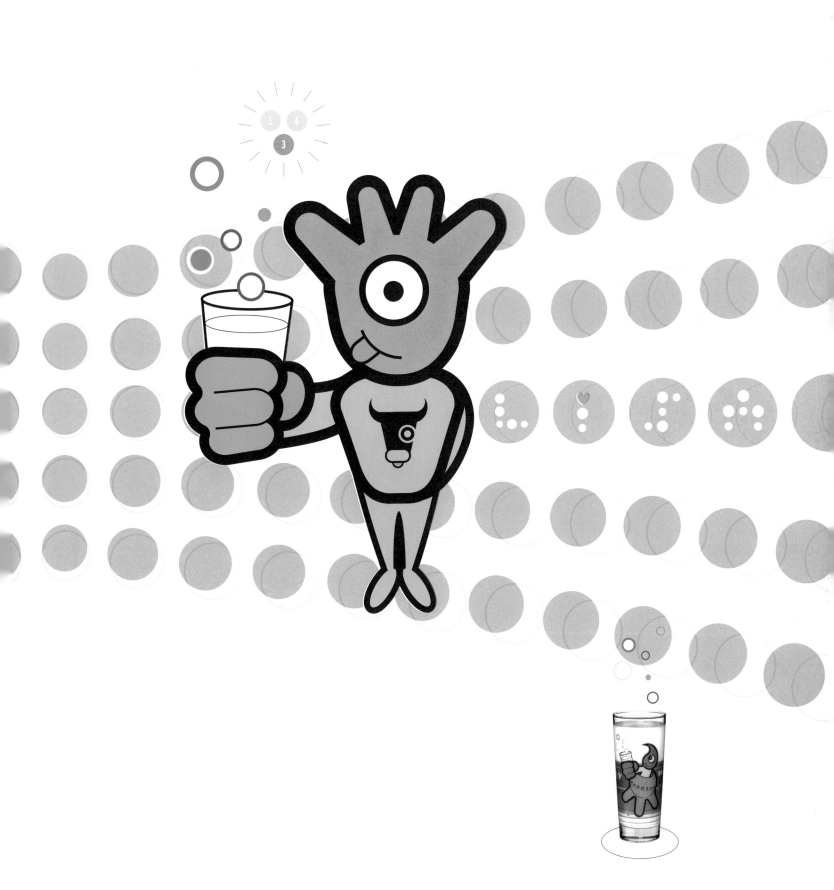

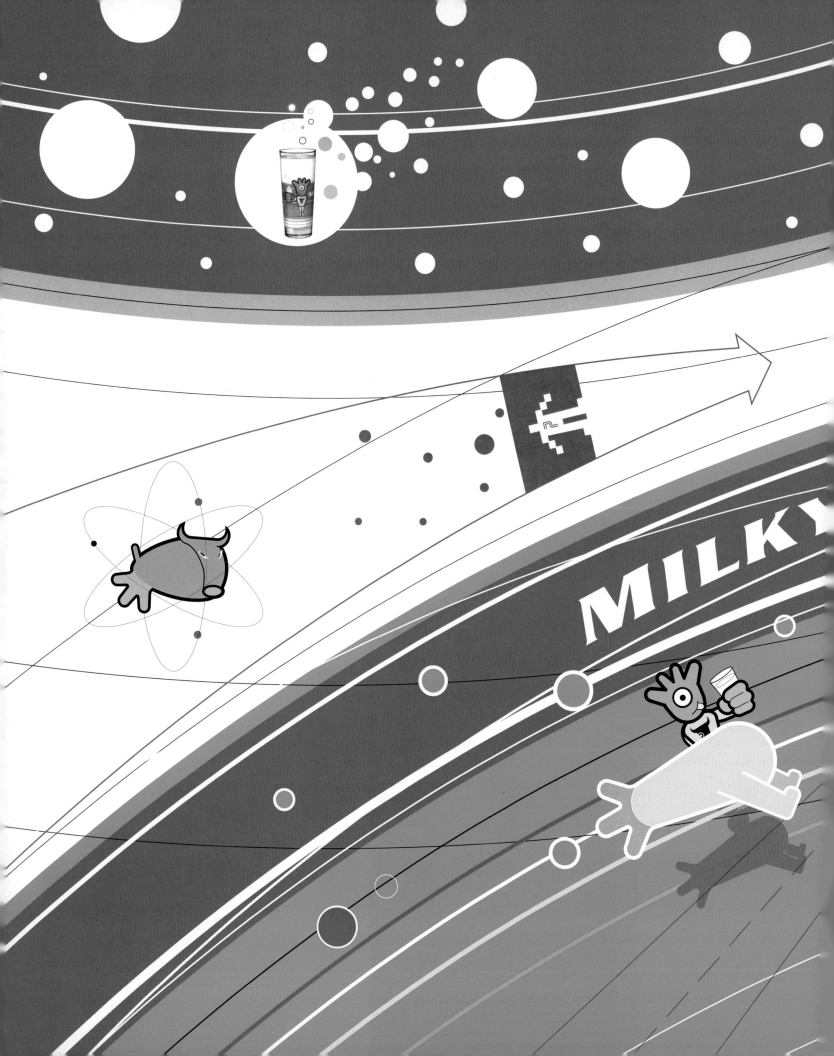

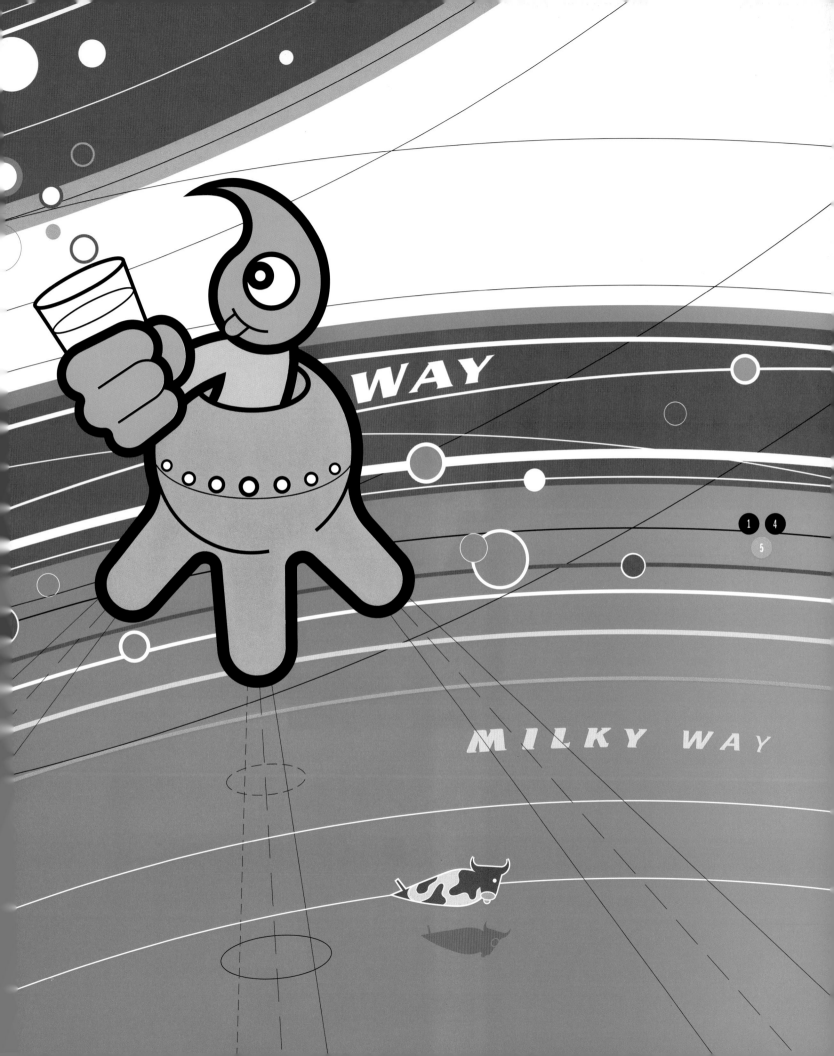

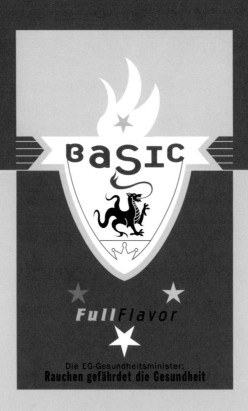

FullFlavor

Die EG-Gesundheitsminister:
Rauchen gefährdet die Gesundheit

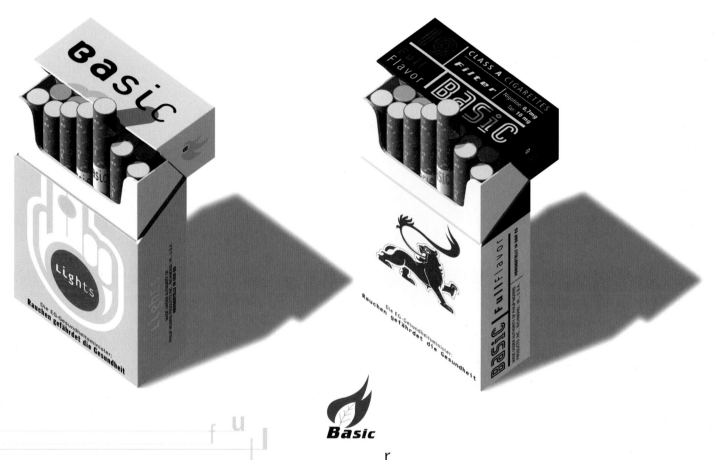

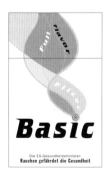

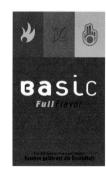

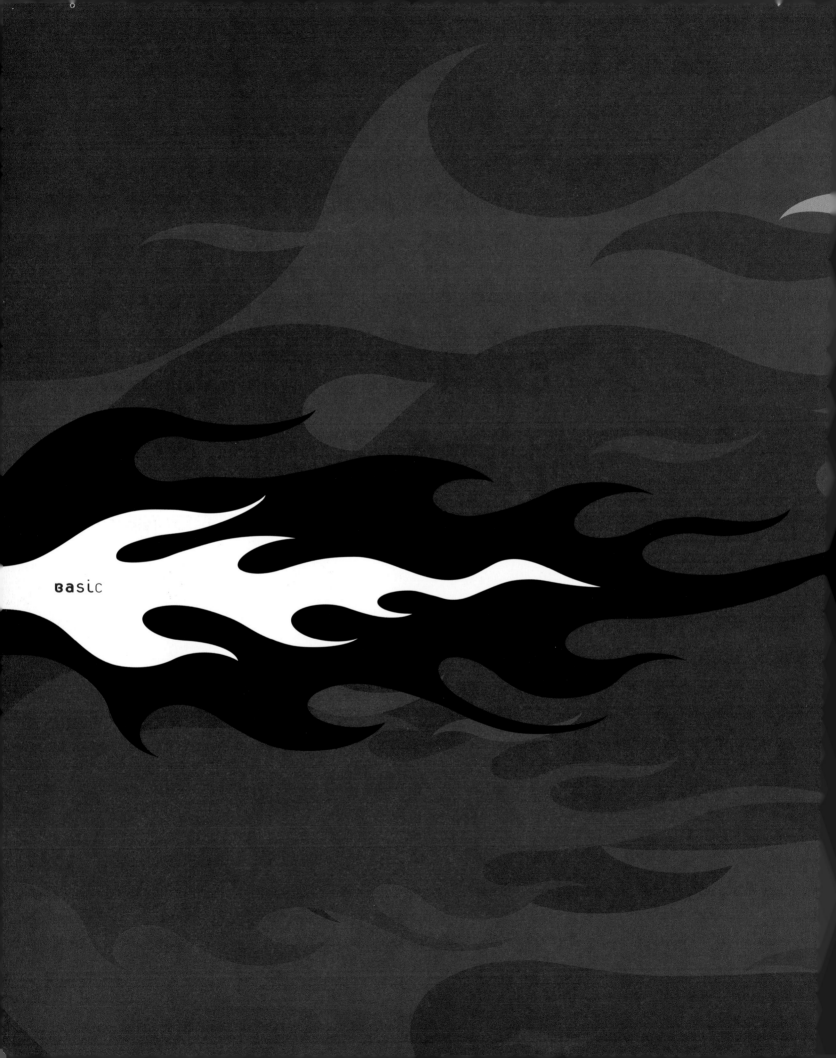

basic

040/041 048/049 056/057 064/065 072/073

042/043 050/051 058/059 066/067 074/075

044/045 052/053 060/061 068/069 076/077

046/047 054/055 062/063 070/071 078/079

046 > 053
G - Show Concept and Showroom Video
"20 years of quattro",
2000

054/055
Intro - "The Real Kick"
Photography: Gaby Gerster

056/057
Nike - Sales Concept Air Max Triax,
1999

058
Nike - Logos
Sport, Spiel, Sprache Tennis Akademie,
Nike Track & Field Akademie,
Premier Cup,
Campaign Logo for Brazilian National Soccer
Team
/059
Nike - Flyer for the International Soccer Game
"Deutschland vs Brasilien",
1998

060 > 063
Nike - Overall Premier Cup Concept,
incl. special packaging
International Soccer Tournament,
1998

064/065
Nike - Sales concept for Nike Geo,
1999

066/067
Intro - "Limbo Without A Pol"

068 > 075
Sony Music - Jam & Spoon - Stella,
1999
Photography: Michael Schwab

076 > 079
Sony Music - Jam & Spoon - Tripomatic
Fairytales,
1994
Photography: Marc Trautmann (076/077)

082/083
Sony Music
Tokyo Ghetto Pussy - You make me feel,
1998
Photography: Sven Leykauf

084/085
Key Visual for the Band Funky Bees

086/087
Universal Music
Silver Shadow - High Society,
1998

088 > 093
Universal Music
Spike Overall Concept,
1998
Photography: T. Hopkins

094/095
Design for a Rave
Love Family Park,
2000

096/097
Various Music Labels

098
Universal Music
Malcom McLaren - The Bell Song,
2000
Design Sven Volz
Photography: Katrin Denkewitz

099 > 101
Universal Music
Andora - Blade Runner,
1998

102/103
Universal Music
Opus 808 - Don't turn away,
1999

104/105
Intro: "Motion In Corner"
Photography: Katrin Denkewitz

106 > 117
MTV Networks - On Air Design Central E
1999
Production: Das Werk / Ralf Ott
Photography: Katrin Denkewitz

118/119
Intro "Sheep In Space"

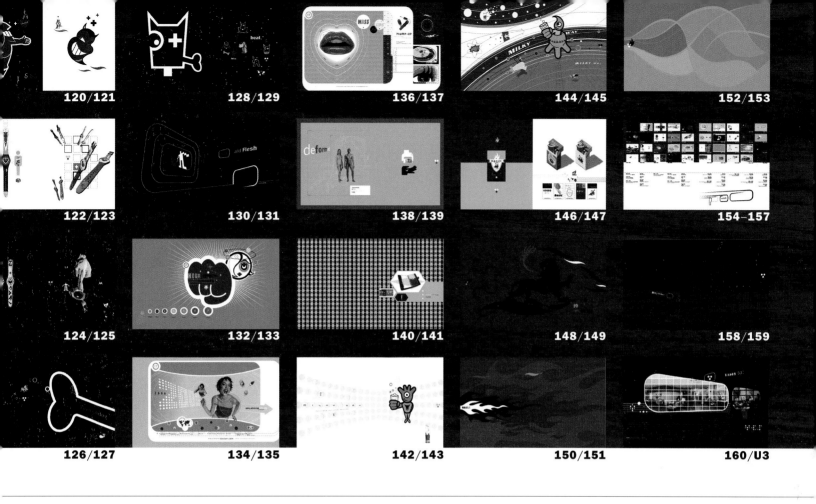

120/121
128/129
136/137
144/145
152/153

122/123
130/131
138/139
146/147
154–157

124/125
132/133
140/141
148/149
158/159

126/127
134/135
142/143
150/151
160/U3

This book is dedicated to my daughter Emma,

Jens 'Lucky' Deusner who has helped me so much with this book and on all other matters,

Tilman Bares who has always given me the right advice,

and Lisa for her heartwarming smile.